The Story of Altrincham

ABOUT THE AUTHOR

Patricia Southern was born in the Altrincham area and was educated at Altrincham County Grammar School for Girls. Armed with three A levels, she went to work in a Manchester bookshop and then at the public library at Sale, where an already developed interest in local history was fostered. She qualified as a librarian at what was then the Polytechnic of Newcastle upon Tyne, and after working in several libraries she returned to the Altrincham area as the Local Studies Librarian at Trafford Local Studies Centre. She lives in Dunham Massey near Altrincham.

The Story of Altrincham

PATRICIA SOUTHERN

AMBERLEY

First published 2008

Amberley Publishing Plc
Cirencester Road, Chalford,
Stroud, Gloucestershire, GL6 8PE

www.amberley-books.com

British Library Cataloguing in Publication Data.
A catalogue record for this book is available from the British Library.

ISBN 978 1 84868 080 7

Typesetting and Origination by diagraf**media**.
Printed in Great Britain.

Contents

Introduction

Altrincham is one of the oldest towns in the Trafford Metropolitan Borough, and indeed it is one of the longest established market towns in north-west England. Whilst it is not specifically mentioned as a settlement in the Domesday Book, its documented history begins in 1290, with the market charter granted by Edward I.

This book is compiled from the extensive collection of photographs held at Trafford Local Studies Centre, part of Trafford Library Service. As such, it does not attempt to provide a complete history of Altrincham, since that would require many more words, and also the emphasis is on pictorial history, and it is not always possible to illustrate some of the aspects of Altrincham's development. Photography was an invention of the mid-nineteenth century, so for illustrations prior to c. 1850, only drawings and documents can be used, and these are not abundant. There are many subjects that cannot be dealt with in pictorial history, but the text accompanying each photographic section covers some of the facts that cannot be illustrated. The library at Trafford Local Studies Centre contains many more items dealing with the history of Altrincham and the other towns of the Trafford area, such as books and pamphlets, large scale maps of various dates starting in the nineteenth century, street directories listing business and private residents, old local newspapers on microfilm, and all the materials for the study of family history, such as census reports for the Trafford area and St Catherine's index of births, marriages and deaths. Local history has a perennial interest and satisfaction, and is inexhaustible because it is interlinked with national and international history; when you think you've finished, you immediately conjure up more questions to answer. If this book reminds readers of things long vanished, related to his or her own personal past, and provides a taster of the nuts and bolts from which local history is constructed, then it will have served its purpose.

Chapter 1
Market Forces

Altrincham's raison d'être is its market, seven centuries old and still flourishing. The market dates from the reign of Edward I, but this does not mean that the town of Altrincham was newly established at that date. There may have have been a pre-Norman times. If there was a small village, it will have been included in the domains of the Saxon lords of Dunham, but there is no mention of Altrincham in the Domesday Book or in any document until Edward I granted the right to hold a weekly market and an annual fair in 1290. The Domesday Book tells us that, at the time of the Norman Conquest, the Saxon lord of Dunham was Elward, or Alfward, whose lands were taken over some time after 1066 by Hamo de Masci. This Norman lord held the lands of Masci in France, so Dunham Massey gained its name from the French town, with altered spelling, but hardly altered pronunciation. According to the Domesday Book, Hamo also held hands in Bochelau (Bucklow) Hundred at Bogedon (Bowdon), Hale and Asceline (Ashley). Though Altrincham is not mentioned by name, it is generally assumed that by this time a small village had already been established, perhaps consisting of a few farms and cottages.

The elements of the place name Altrincham have been interpreted in different ways. The older version of the name, now entirely discredited, relied upon the invention of an imaginary personage called Tring, a name for which there is no documentary support of any kind. It was thought that the place name developed when the element -ham, meaning village, was attached to the man's name, thus producing a phrase that was though to denote 'the settlement of Tring'. Nowadays this early theory has been overturned. The name Altrincham is considered to embrace three separate elements instead of only two, firstly the –ham element meaning village, secondly the –inga element derived from Old English –ingas, meaning 'the people of', and thirdly the Altr- element referring to a person called Aldhere, which is a genuine and securely attested Old English personal name. Thus Altrincham means 'the village of the people of Aldhere'. No one knows who Aldhere might have been, nor when he lived. The interpretation and all three elements of the place name are illustrated in the earliest documentary evidence, which is found in the market charter of 1290, where Altrincham is written as Aldringeham.

This royal market charter granted by Edward I is the first known mention of Altrincham as a settlement, and therefore the first time that the town enters recorded history. The wording of the

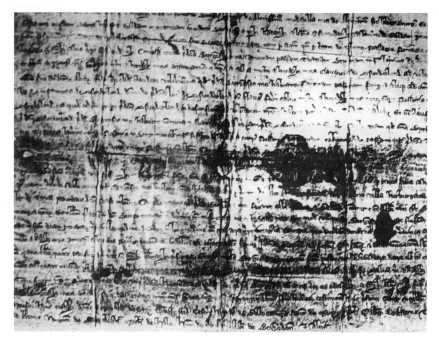

The charter of Hamo de Masci granted to the burgesses of Altrincham, probably in 1920, after the Royal charter was signed by King Edward I. This is the basis upon which Altrincham was established as a market town.

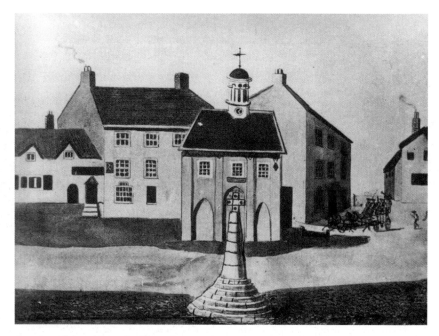

Drawing of the Old Market Place showing the market cross in front of the Market Hall with the Town Hall on the upper floor. The present market cross that was erected as part of the charter celebrations in 1990 is based on this design with the cross on top.

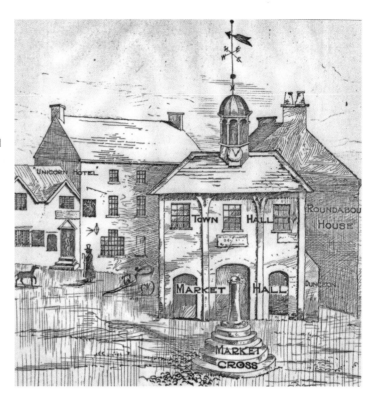

Right: This drawing is very similar to the previous one, except that the dungeon at the back of the Market Hall is labelled, and the market cross is truncated.

Below: The Old Market Place in snow, showing the cab stand with horse-drawn cabs waiting for passengers. There is no date on the photograph but it was probably taken around 1900. At the end of the nineteenth century, B. Goodall and Co, coach proprietors, and George Baguley, carrier to Manchester, ran their businesses from the Old Market Place.

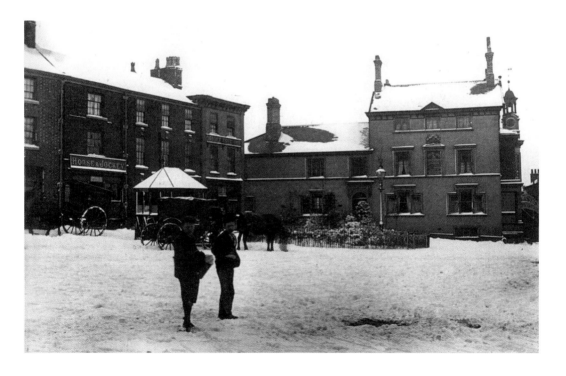

charter makes it clear that the grant was made to Hamo de Masci, the fifth lord of that family, permitting him to his heirs to hold in perpetuity a market each week on Tuesdays at their manor of 'Aldringeham'. There was also to be a fair for three successive days, originally on the eve, the feast day and the day after the feast of the Assumption of the Blessed Mary, 14-16 August. The date had to be changed in the early fourteenth century, because church officials all over the country rebelled against the sinful practices of the people who attended the fairs. There had once been a close association between church and fair, since many fairs were held inside the churchyard, but this practice was eradicated in 1285. This ruling predates the establishment of the fair and market at Altrincham, and in any case the nearby church authorities would not be affected by the market

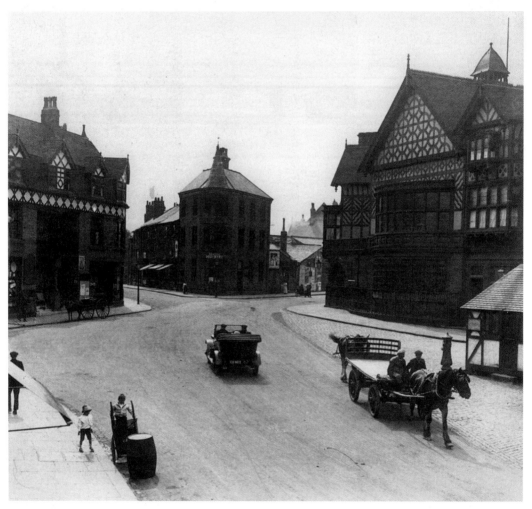

View from the Old Market Place looking towards the present market. The impressive half-timbered building on the right side of the road was a bank, called Bank House in an 1898 street directory. The bank buildings were erected in 1887, for Sir William Cunliffe Brooks. The bankers are listed in the 1898 directory as Cunliffes, Brooks & Co, and the cashier is named as Richard R. Kirby. By 1906, Lloyds Bank is listed, and Richard R. Kirby is named as the bank manager. Facing the bank, on the opposite side of the road, the building displaying timbered decoration just underneath the gable windows was also built for Sir William Cunliffe Brooks, as business premises. It dates from the 1890s.

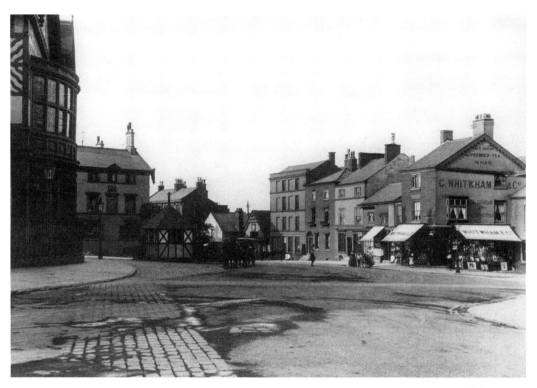

The Old Market Place with view of the cab-stand looking towards Broadheath. Many of the buildings around the Old Market Place date from the Georgian period, at least as far as the façades are concerned, but older buildings may be incorporated into the offices and shops photographed here. Whitwham's shop selling tea and coffee was established some time before 1898 and survived until at least 1939. In 1916 the proprietor placed an advert in the Altrincham street directory, proclaiming 'specialities: - Premier tea. Coffee roasted daily. Italian warehouse. Grocers and Wine Merchants (cask and bottled ales).' The building may date from the seventeenth century, and contains timber framing within its fabric. In the middle of the photo, just behind the horse and cab, the last thatched building in Altrincham can be glimpsed.

because the parish church lay at Bowdon. Many churches, however, were situated very close to the markets, and indeed trading was often carried out inside the church porch. In 1448 it was forbidden to hold any fairs on Good Friday, Ascension Day, Corpus Christi and the feast of the Assumption of the Virgin Mary. Accordingly, the inhabitants of Altrincham changed the date of their annual fair to the Feast of St James on 25 July, so the three day event ran from 24 to 26 July. By a tortuous pronunciation of St James, the event was known colloquially as the Samjam fair. An additional fair was started for an extra three days in autumn, running from 10 to 12 November. The royal charter of 1290 specified that neither the market nor the fair was to be a nuisance to any neighbouring markets or fairs.

The establishment of a market could, on occasion, involve the creation of a completely new town on virgin soil. In the case of Altrincham, there may have been a hybrid development, combining an existing small settlement with a brand new layout as plots were marked out for the people who were to take up residence there. As has been pointed out, the mention of Aldringeham as part of the manor of Hamo de Masci presupposes that there was a village of some kind somewhere in the vicinity, which would be elevated in status when the market was established. In a recent publication on Altrincham, it is suggested that an unauthorised market may have been

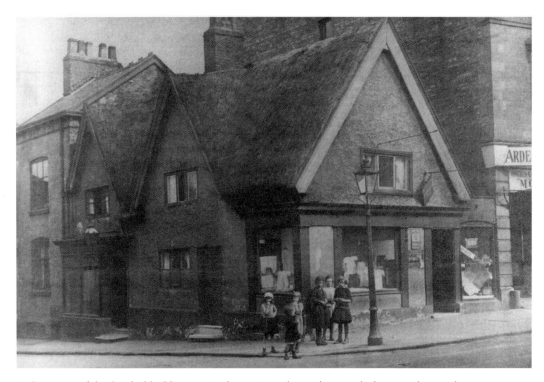

A closer view of the thatched building seen in the previous photo, photographed at an unknown date, probably in the 1920s. It was situated on the corner of Church Street and Victoria Street, at No.20 Old Market Place. The building had a varied history. In 1898 it was occupied by Frederick Youlton, provision dealer, and by 1903 Harry Brown had taken over with his cycle shop, trading there until about 1912. He also had a workshop at 45a Church Street, and another shop in Hale. In 1913, Frank Johnson, furniture broker, took over for about two years. Then during World War One Miss Florence Dobbins converted the shop to refreshment rooms. The building next door was a garage operated by Arden and Bull at the time when the photograph was taken. The predecessors to Arden and Bull were listed as Cragg & Sons, motor garage, who took over the building in 1913 after it had been empty for two years. Prior to that the two occupiers were mineral water manufacturers, under three different names, Brantingham and Raingill, Leigh and Co, and then Groves and Whitnall Ltd.

operating for some time before the royal charter was granted. Though there is no solid proof, the Old Market Place is the most likely site for any settlement and rudimentary market

Altrincham ranks among the great number of towns in England that received their market charters in the thirteenth century. A few charters were granted in the twelth century, but the great majority belong to the following century; over 3,000 such grants were made between 1200 and 1300. Many of these were granted by successive kings to their royal estates, but many were also granted to individual landholders to reward them for their services to the Crown. The thirteenth century marked the heyday for markets; there were markedly fewer grants of market charters in the fourteenth century. Thereafter, there was an economic decline, and not all the market towns survived. Altrincham was one of the luckier ones, and perhaps better managed, since after its establishment, the market retained its vitality, surviving through the centuries despite recessions, wars, plagues and all manner of hindrances.

Once the King had granted the market charter in 1290, a framework had to be established in which the market could be operated. Without mentioning the market specifically, the fifth

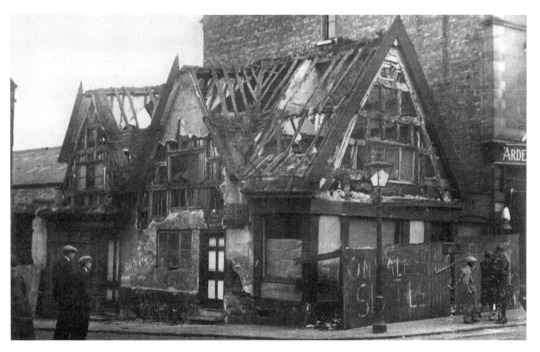

Another view of the thatched building dilapidated beyond repair in 1932.

Lord Hamo of Dunham Massey, a descendant of the original Hamo, granted another charter to Altrincham, changing its status to that of a borough. This is an important development for Altrincham, illustrated by the fact that in the thirteenth and fourteenth centuries there were only just over thirty boroughs in the whole of the north-west. In Cheshire, the establishment of boroughs was relatively slow. Between the eleventh and mid-seventeenth century, besides the borough of Altrincham which was created in the thirteenth century, the lists of boroughs includes Chester, Congleton, Ellesmere, Frodsham, Knutsford, Macclesfield, Nantwich and Stockport. Borough status meant that the town and its market would be administered by a corporation, or a group of the chief residents. The free inhabitants who held land within the borough were called burghers, or burgesses, and the charter of Hamo V specifies the privileges and duties of the burgesses of Altrincham. They were not obliged to pay tolls to the lord, or to work on his land, as all the peasants were still obliged to. This was one way of attracting settlers to the newly elevated town. Anyone expressing an interest in coming to live there would require land upon which to build a house, accompanied by a plot of cultivable land where he could grow food. Some of the original plots marked out on either side of the Old Market Place, and on both sides of Church Street, have been identified by Don Bayliss in *Altrincham: a History*. In return for the privileges and the freehold of a plot of land, the burgesses were expected to govern the town and keep law and order.

The tolls and dues from the market stallholders were fixed at periodic meetings of the burgesses acting in concert with the lord of the manor, to whom the monies collected were paid. It was obviously a profitable enterprise for a lord to establish a market, which perhaps explains why so many charters were granted in the thirteenth century. It would be an excellent way to supplement income from lands and tenants' houses, and not a few barons saw the establishment of a market as a way of paying off debts.

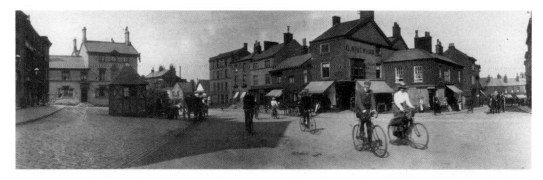

Panoramic view of the Old Market Place, with cyclists in the foreground. This photograph was taken using a Kodak panorama camera, first developed in 1990. This photograph is reproduced from an older print by Mr D. Rendell.

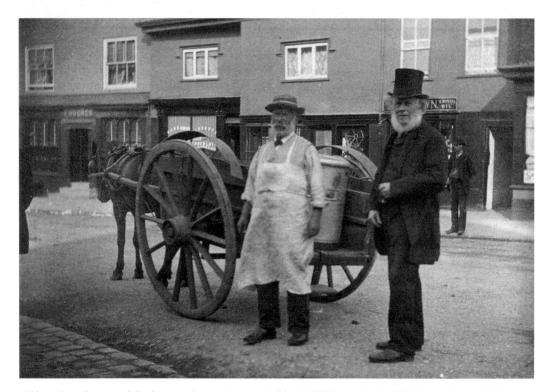

Gibbon the milkman with his horse and cart, photographed by H. Wilkinson, in the Old Market Place c.1880.

In order to minimise competition from other markets, there were laws to stagger market days throughout the week in certain areas, and in order to limit the number of markets in any one region, it was decreed that they should lie at least six miles apart. This ruling was based on a calculation of the distance that anyone could be expected to walk in one day, which set up at a round trip of twenty miles. Allowing time for the walk to the market, for trading whilst there and for returning home, this hypothetical twenty miles was divided into three parts, resulting in a statutory distance between markets of just over six miles. It was forbidden to walk home by

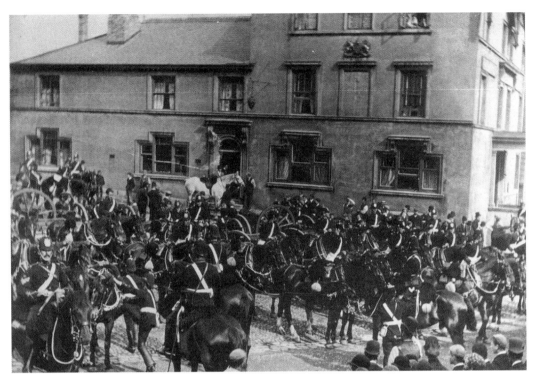

This photograph shows the Manchester Artillery with the Unicorn in the background.

night, because of the danger of being attacked by thieves and robbers – not much has changed in the last seven centuries.

On market days, one of the major concerns was with law and order, for two reasons. Firstly the trading had to be regulated, unfair practice stopped, weights and measures checked and so on. For the purpose of checking weights, an official called the Ponderator was appointed. Secondly, it was sometimes necessary to control violent disputes, brawling, and fisticuffs, which might break out where many people were gathered in one place, parting with and accepting ready cash, having access to alcohol. Everyone who came to market to set up his stall was subject to the same rules, and there were laws to prevent anyone from buying goods and selling them at a profit on the way to the market, a practice known as forestalling and a word which has survived into modern English. In the mediaeval period the responsibility for overseeing the market would probably have fallen to the steward of the lord of Dunham Massey. He would preside over the Pie Powder Court, dealing with cases that came before him on market day. By the very transitory nature of the market, law and order had to be enforced on the spot, and punishments and fines levied there and then, otherwise guilty parties could simply melt away and disappear, never to return. The name Pie Powder derives from the French term, pieds poudreux, meaning 'dusty feet', referring to travellers who had come to market, though in England a term meaning 'muddy feet' might have been a more apt description. From 1640 onwards, the responsibility for the markets devolved upon an official called the Clerk of the Market, who was generally appointed by the lord of the manor, or by the town mayor.

Usually there was a market cross to make it clear where exactly the market was situated. The use of the cross perhaps sanctified the meetings on market days, and the platform that often

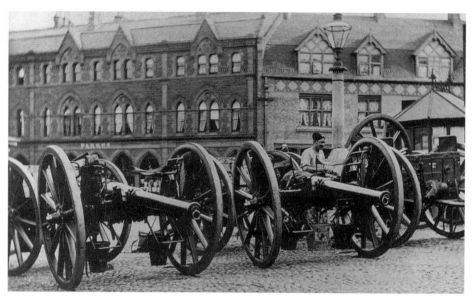

The Old Market Place was used for assemblies such as this one, where the Manchester Artillery put on a display in 1904.

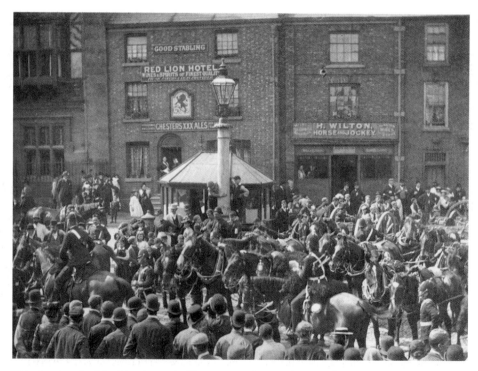

This photograph of the Manchester Artillery was stuck onto a homemade postcard, and sent from Manchester on 29 June 1925. On the back is written 'We intended going to Delamere yesterday for a picnic but the car did us a dirty trick and wouldn't go. It was a case of have you ever been had. E. has had to get the bus to Bollington too. Much love, L.'

accompanied the crosses could be used as a dais or tribunal where the overseer of the market could address the whole assembly. The market cross-situated in the Old Market Place is not the original one. It is based on an old depiction of the cross and was erected in 1990 as part of the charter celebrations of 700 years of Altrincham's history. Though it is not venerable and ancient like the market cross at Lymm, it still gives an idea of how it might have looked. Often there was a tollbooth in the market place, where the stall rents could be collected; it was usual for local people to trade first, before the outsiders were given a stall, but if outsiders were willing to pay increased rents, they were permitted to set up their stalls as soon as they could. In many markets, a market hall was often built, but in Altrincham the location of the mediaeval stalls or any permanent building is not known. Drawings of the Old Market Place in the seventeenth century show the market cross and the Town Hall above the Market Hall, in front of the Unicorn Hotel.

One of the most important factors in establishing a successful market was its ease of access. Routes to and from the town where the market was to be held needed constant maintenance, especially for wheeled traffic, and in some cases roads were specifically constructed to make market places more accessible. In the mediaeval period these roads were called portways, from the Latin for gate (porta). Altrincham was fortunate in being close to the Roman road that connected the legionary fortress at Chester (Deva) to the smaller fort at Manchester (Mamucium), but the settlement was not established on the road itself. A glance at the old 25-inch-to-the-mile maps will show that the Roman road, known as Watling Street and now marked for part of its length by the modern Manchester Road and Washway Road, runs dead straight south-westwards from Manchester, until

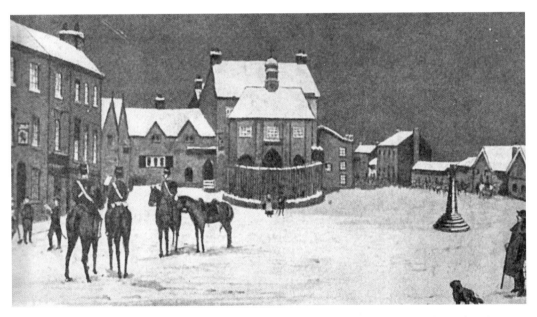

During the 1745 rebellion, the cavalry of Bonnie Prince Charlie's army arrived in the Old Market Place on 1 December, looking for quarters. According to Nickson in *Bygone Altrincham*, some of the troopers stayed at the Red Lion, and others found billets at a farm near the site of St John's church. The story goes that an innocent bystander watching the men and horses from his vantage point in Victoria Street (which probably was not called by that name then) was deprived of his stout boots by one of the cavalry men. Another story concerns the events of the following day when the troops were leaving to join the main force at Prestbury and Macclesfield. One of the Scots was involved in a fight with the landlord of the Bleeding Wolf Inn. The unfortunate trooper was killed with his own sword, and was supposedly buried on Hale Road.

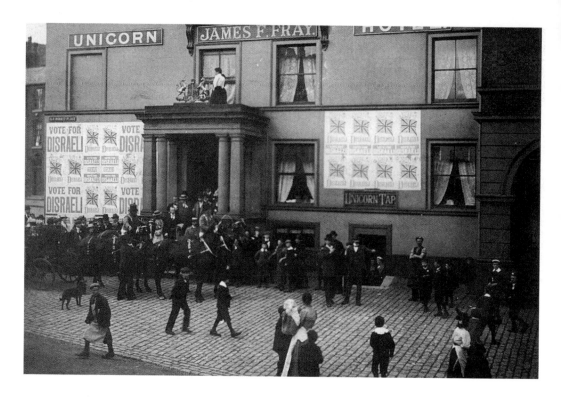

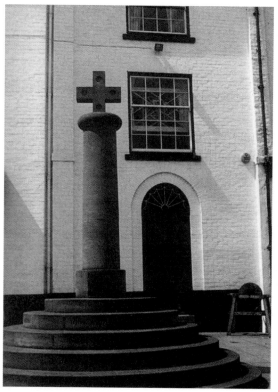

Above: A gathering at the Unicorn Hotel, with posters proclaiming 'Vote for Disraeli'.

Left: The new Market Cross erected in 1990 in celebration of the market charter of 1290.

Modern view of the Old Market Place, showing what used to be the Red Lion and the Horse and Jockey.

Another modern view of the Old Market Place, looking towards the Unicorn Hotel, now the Market Tavern.

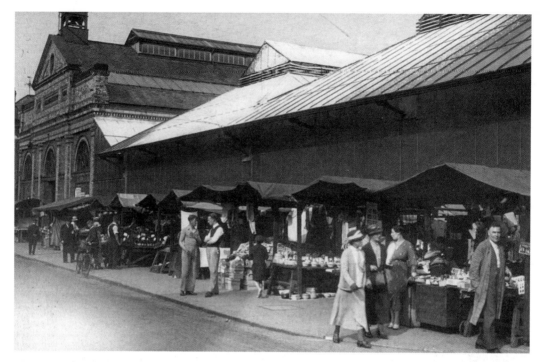

As traffic increased through the Old Market Place it became clear that a new location would have to be found for the market to function properly. From the 1860s onwards it was on the agenda to find a new site and in 1879 the Earl of Stamford gave the land where the present Market Hall is situated. The 1874 Ordnance Survey map of Altrincham shows that there was a planted area next to Shay Lane, (which became Shaw Lane and then Shaw's Road), and this plot was where the Market Hall was built. The roads around the new market were renamed, to bring them in line with the placing of the old market: the Market Street of today was once called High Street, leading from the Old Market Place into a narrower street called Bowdon Lane. This view shows the Market Hall in the 1920s.

roughly Broadheath, and then disappears. South-west of Altrincham, the course of the Roman road can be picked up again, heading for Chester, at a point just after Lymm Corner where the M56 joins the trunk road. The section of the road in between these two points diverts to Altrincham itself; Don Bayliss suggests that when the market charter was granted, the road may have been deliberately closed between Broadheath and Highgate so that any traffic moving along the route had to pass through the town. This shows a remarkable initiative that goes beyond the three modern marketing criteria of location, location, location, in that instead of siting the market in the road, the people of Altrincham brought the road to the market.

Control of the market in the eighteenth century was the responsibility of the Court Leet, a revival of the mediaeval manorial court dealing with minor offences and empowered to make byelaws. This lasted until 1878, when great changes were made to the market. Supervision passed to the Local Board and a new market hall was built. Towards the end of the nineteenth century the inadequacy of the accommodation for the market on its old site had become obvious, and from the 1860s a new location was sought. In 1879, the Earl of Stamford gave to the town the land where the present Market Hall is situated, at a chief rent of two old pence per square yard for one year. The hall was accordingly built in the new site and has been in use ever since. It was renovated in 1990 and a Blue Plaque erected as part of the charter celebrations.

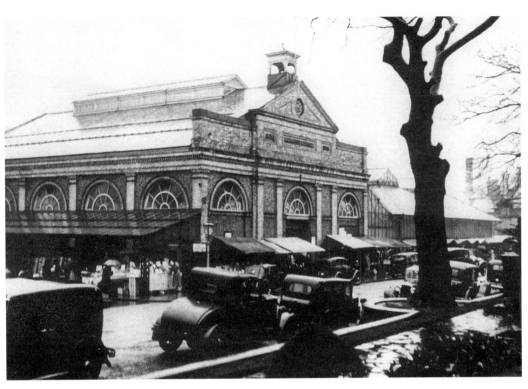

Above and below: These two views of the Market Hall, with parked cars lining the street, were taken in the 1930s.

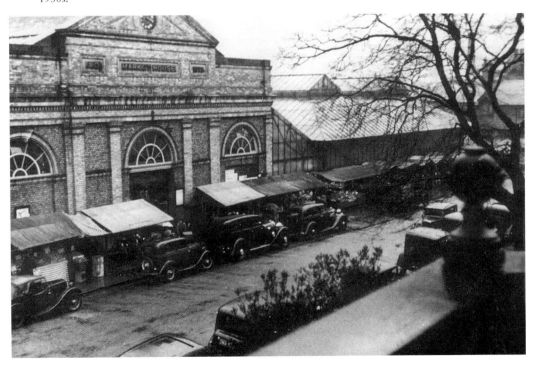

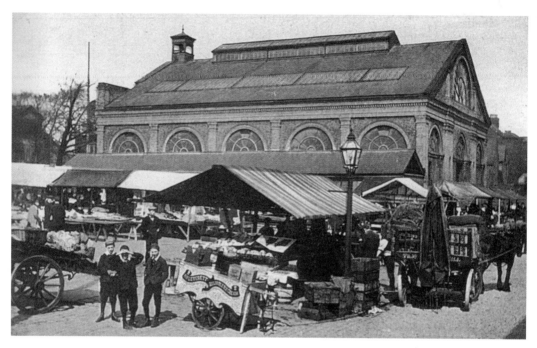

The Market Hall and outdoor stalls at an unknown date, probably around the turn of the nineteenth and twentieth centuries.

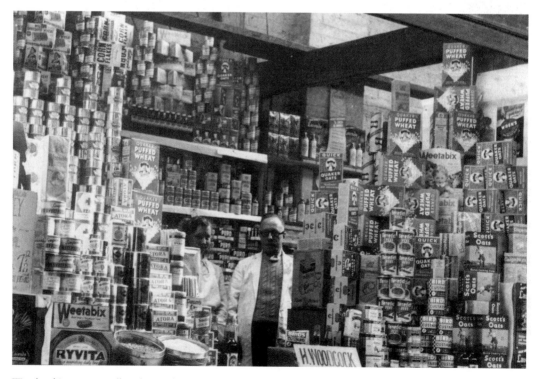

Woodcock's grocery stall in the Market Hall.

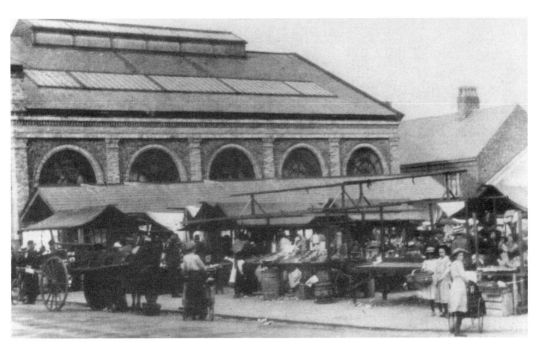

The Market in 1915.

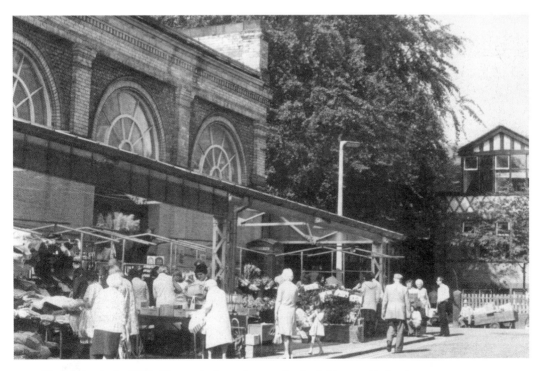

The Market in the 1970s. Not much changed except for the fashions and hairstyles.

Chapter 2
Shop Till You Drop

After the establishment of the market, traders would gravitate to the town to set up their businesses. The nature of the mediaeval trade in Altrincham is not known, but it can be assumed that perhaps the residents of the town supported themselves by a mix of agriculture and trading activities. Photography is a feature of the second half of the nineteenth century, so the pictorial record of the town before the 1850s is sparse, but this is perhaps not such a great loss, since the shops and businesses of Altrincham did not develop until the eighteenth and nineteenth centuries.

Altrincham is one of those relatively few towns for which the Board of Health map has survived. This detailed map was drawn up in 1852, as one of a great number of surveys made in many towns in response to the cholera epidemics of the 1840s. Following the epidemics, the concept gained ground that bad sanitation may have been the cause of the rapid spread of contagious diseases. The Public Health Acts were passed with a view to installing drains and sewage systems in towns, which in turn necessitated an accurate survey to show the location and extent of each building in the town. For the purpose of documenting the number of shops in Altrincham in 1852, this map, and its accompanying book of reference listing the buildings and their owners, is invaluable. For instance Railway Street is shown directly connected to George Street, since the map was drawn before the building of Stamford New Road. It is along this Railway Street-George Street axis that several shops were established, but they were interspersed with houses and gardens, and there were smithies and several piggeries in the back yards attached to these houses, so the aromatic atmosphere of Railway Street and George Street was perhaps a little different from that of today. It is not possible to discern from the map and the book of reference the nature of the shop or what the business dealt in, but the information that is provided is an indication of how few shops there were in 1852. Of the sixteen establishments on Railway Street between The Downs Hotel and Regent Road (then called Chapel Walk), only eight were listed as shops. On either side of George Street large areas to the north-west and the south-east were taken up by gardens and open spaces, and out of about twenty-three buildings on the north-west side only five were shops, and there was one shippon, presumably for dairy cows, one stable, and a yard with piggeries. On the opposite side there were about seventeen houses and yards or gardens, and three shops.

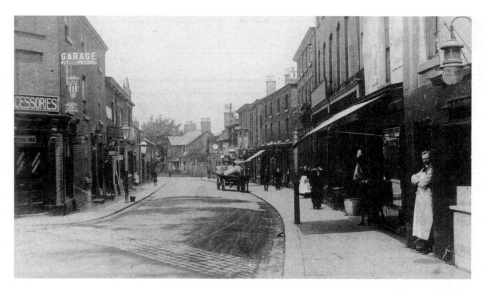

Church Street, looking from the Old Market Place in the direction of Broadheath, before the road-widening scheme was put into operation, necessitating the demolition of much of the property in this photo. The garage on the corner, listed as No. 1, Church Street, was once a coffee tavern, run by Jules Emile Metzger from sometime before 1898 until about 1908-09, then it changed hands and also its function to become a motor garage, where from 1909 to 1910, R.E. Moynihan is listed as the proprietor. The shop in the foreground on the left-hand side is a butcher's shop, run by George H. Wood.

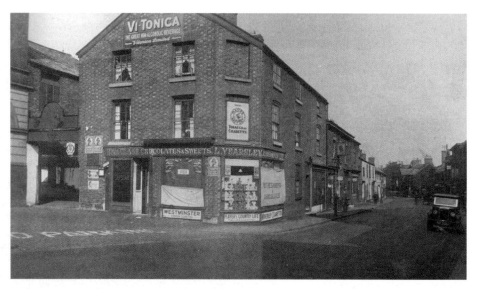

A later view of Church Street, once again looking in the direction of Broadheath. By 1927 the building on the corner, shown as a garage in the previous photo, had been converted into a sweet shop with the name L. Yearsley over the door. This is Lawrence Raymond Yearsley, listed in a 1927 directory as a confectioner. The garage that used to be listed at No. 1 still existed at the time, but it was no longer given a number on Church Street, since it no longer had a front office at No.1, but had migrated round the back of the sweet shop. The entrance to it can be seen with an Automobile Association sign above it. Also, just visible on the far left of the photograph is the Old Town Hall, next to the Unicorn Inn, which is not in the picture.

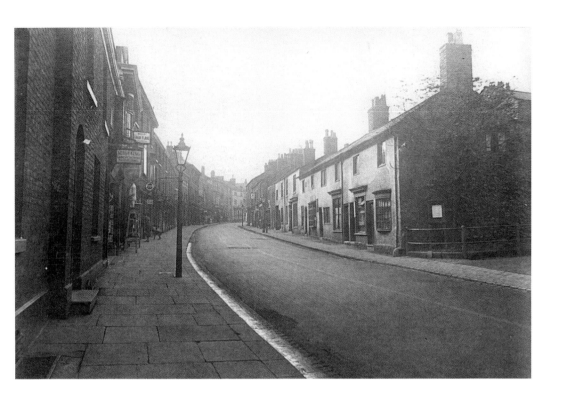

Above: Another view of Church Street. When this photograph was taken the property was soon to be demolished before the road widening began. On the left, a small sign at roughly second floor height, just next to the lamp standard in this photo, proclaims that this is the premises of Nellie King hairdressers, and in the 1927 street directory, she is listed as Miss Helen King, 36 Church Street. Presumably she either ran her business upstairs, with a shop below, or she occupied the ground floor and a tenant lived above the shop, since also listed at No.36 is Herbert Hill, motor engineer.

Right: When the new Market Hall was built the road names all around the market were changed. The present Market Street was once called High Street, and the present High Street is a different road running at right angles to the original one. This drawing shows Charles Balshaw's versatile shop, on what was then High Street, in 1858. Balshaw's was a printing shop, a bindery, a bookshop and a circulating library.

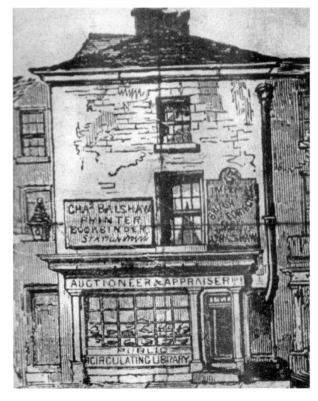

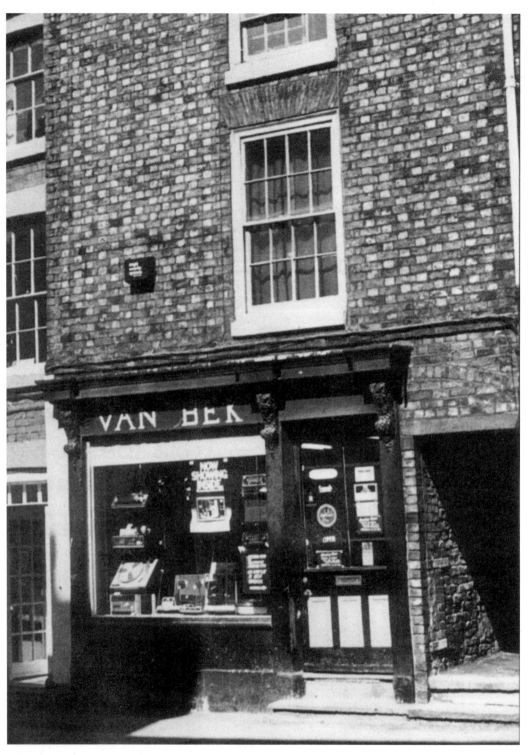

In this photograph taken in 1974, High Street is now called Market Street, and Balshaw's shop is occupied by Van Bek's Hi-Fi store.

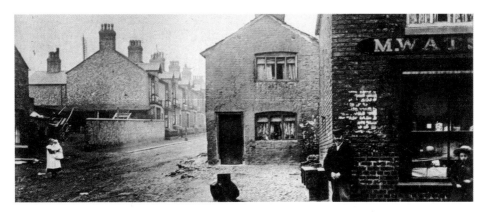

Looking from George Street into High Street, all now obliterated by the modern road layout and the shopping precinct. Old maps clearly show this vacant lot on the right-hand side of the High Street, which remained unclaimed until the 1930s and later. The cottages set back from the road were demolished before 1910, and replaced by terraced housing parallel to High Street. According to street directories, the shop labelled M. Wats(on) on the right of the photograph was occupied by Mary Cannon, fruiterer, in 1898; by 1906 she is listed as Mrs Mary C. Cannon and in 1908 she is called Mrs Mary Concannon, presumably a case of mishearing when names were asked by the compilers of the directories.

During the next fifty years there was a marked increase in trade. In 1897, concern was expressed about the 'rapidly fading traces of the past', and a pamphlet was issued on the subject, to describe the main businesses and the rapid development of the town, 'in the last forty or fifty years', from the 1840s and 1850s. Personal memories of the town, collected in 1897, all concurred in describing Altrincham as a village, with only about three shops between the foot of The Downs and the Malt Shovel public house, and a moss where cattle grazed at the Bowdon and Hale end of Railway Street.

One of the oldest established businesses in Altrincham was Coupe & Hillkirk, Italian warehousemen, at 58 George Street. It was founded by John Barrow, Wesleyan preacher, and was eventually handed over to his two apprentices, William Collins & Samuel Warren, who changed the name of the business, appropriately, to Collins and Warren, selling general groceries, ale and stout, medicines, brushes, corn, and grass seeds. In the 1850s, James Cowsill set up his grocery and provision dealers store in Altrincham, then moved from his first shop to George Street. He was famous for his cheeses, especially Cheshire cheese, which he obtained from Nantwich. He also ran a bakery in the shop. His opening hours were rigorous, from 7am until 10pm everyday from Monday to Thursday, closing even later on Fridays and Saturdays at 11pm and 12 midnight. Nowadays the 24-hours shopping phenomenon is considered to be an innovation, but it was almost achieved in the later nineteenth century.

Another grocery store on George Street was Shuttleworth's at No.28. William Shuttlewoth started out as an apprentice at Royle's shop on The Downs, then set up in his own business in 1871. It was estimated that the catchment area of Shuttleworth's included all villages within an eight-mile radius, providing groceries and specialities such as Danish and Irish butter, Wiltshire hams and and smoked bacon, and a wide variety of cheeses.

In 1884 two Manchester businessmen set up shop in Altrincham, Mr Burston, who had worked for some time in shops in Manchester, and Mr Nixon, who had been manager of Nathaniel Gould & Co. Learning their trade in the city the two men brought their knowledge and expertise to Altrincham supplying all the stock that grocers and wine merchants normally sold, plus patent medicines, brushes and some hardware. They established other shops in Peel Causeway, Stretford, and Southport.

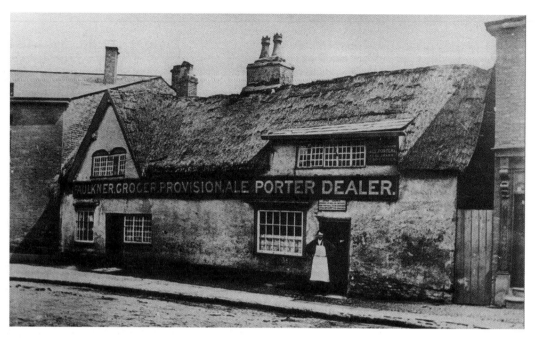

At No.5 Railway Street, on the same side as the entrance to Goose Green, there was once Faulkner's shop, advertised here as provision dealer, selling ale and porter. In a directory of 1864 Thomas Faulkner is listed as grocer and beer retailer at this address, and he can be traced back as far as the 1852 Board of Health map, for which the accompanying book of reference lists him as the owner and the occupier of these premises, which are described as a Public House, together with gardens at the rear. The configuration of the roads at this juncture where Railway Street once met up with George Street, was altered when Stamford Road was cut through.

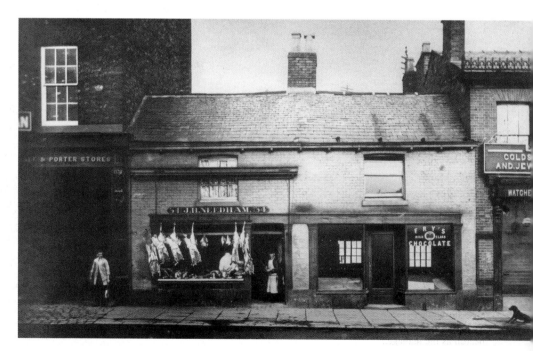

Opposite below: Railway Street at the end of the nineteenth century, on the side facing Lloyd Street and Goose Green. The Downs Hotel, not shown here, lies a little further up the road to the left of the buildings in this photo. At No.36, just off the left-hand edge of the photograph, is J. and H. Dean, seed and wine merchants (the last letters of the name Dean can be seen above the entrance). Next-Door at No.34. is the butcher's shop of J.H. Needham. No.32, with Fry's chocolate advertised in the window, appears to be an empty shop in this photo. A fruit shop is listed here in 1898 run by Benjamin Battman. Further to the right at Nos.28 to 30 is Frederick Johnson, goldsmith, jeweller, and watchmaker.

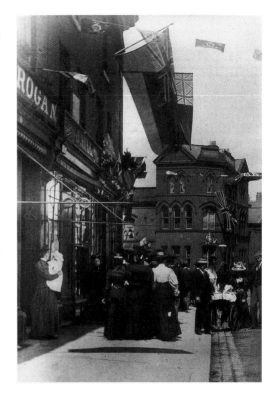

This page: Railway Street, with bunting, looking towards the station. The occasion may be the Diamond Jubilee of Queen Victoria in 1897. The watchmaker's premises run by William Grogan is seen on the left at No.20 Railway Street, then at No.18 there is J. Hill's fishmonger's shop. On the right-hand side, on the corner where the road from Goose Green emerges, is the bank, listed in 1898 as the Lancashire and Yorkshire Bank Ltd, with George J. Beaton as the manager.

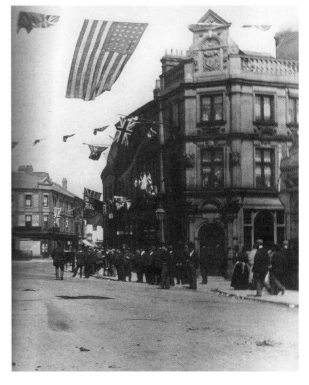

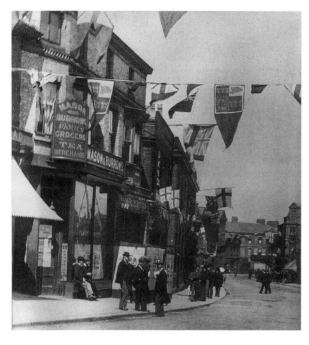

This page: Railway Street viewed from the bottom of The Downs. On the left can be seen Mason and Burrows, family grocers and tea merchants, whose address is No.4 The Downs. The shop is attested in the 1898 street directory, but by 1902 it is listed as George Henry Wainwright, grocer, and also Williams Deacon Bank Ltd. with no mention of a grocer's shop. After the establishment of the tram service to and from Manchester in 1907, the office next door to the bank at No.2 The Downs was the Altrincham headquarters of the Manchester Corporation Tramways. The tram terminus was located at this point where The Downs joined Railway Street. On the right of the photograph the signboards can be seen for Cragg's cycles, and for Oram and Evans. The bicycle shop run by H. Cragg & Sons at No.55 Railway Street, is listed in directories from 1898 to about 1910, when the shop appears to have been empty; by 1916 it had been taken over by Freeman Hardy and Willis. Oram and Evans was a large fishmongers shop listed in 1898 at nos 49 and 51 Railway Street, but by 1902 it had shrunk to only one shop at No.49, run by William Evans, fishmonger. The shop next door at No.51 was occupied by Miss Maggie Howard, confectioner. Miss Howard presumably got married at some time before 1910, since she had become Mrs Maggie Pearson, confectioner, by that date.

At the turn of the nineteenth and twentieth centuries, baker's shops were located, among other areas, on Oxford Road and Station Road. John Lewis established his bakery on Station Road in about 1885, having opened up on Church Street in 1874, taking over the business from John Davenport.

The Bowdon Bread Company was located on Oxford Road. It was founded in 1886 by Robert Martin, and was one of the first bakeries to install a Werner and a Pfleiderer patent kneading machine. This machine-made bread was said to be better than the hand-kneaded variety, but then of course the bread had to be sold at a profit, so the claim that it was better could be put down to marketing technique. The Bowdon Bread Company also had several varieties of flour. Another bakery was Sothern's, which started out in 1820 opposite the Unicorn and in the Old Market Place, and successively moved to Chapel Street, then Church Street, then Oxford Road, and then Peel Causeway.

A glance at the street directory of 1900 shows how rapidly Altrincham had grown in the previous half century. Shopping on Railway Street was as diverse as it is today, with four butchers' shops, three confectioners, two chemist's shops, three tobacconists, two fishmongers, two fruit and vegetable shops, and two grocery stores. You could also buy a bicycle, have a suit made, have clothes dry cleaned, buy a watch, open an account at the Lancashire and Yorkshire Bank on the corner of Railway Street and Goose Green, have a pair of boots made, buy stationery, and if you were wealthy enough, purchase fine art from T. Scott & Co at No.13, Railway Street. George Street had also developed by 1900. There were only a few houses inhabited by individuals by this time, reversing the situation of 1852. There was a choice of at least eight butchers, ten grocery shops, two tripe shops, and six drapery stores. At this date you could also buy a saddle, browse through a selection of glass and china, have your photograph taken, have your hair dressed, buy a hat, buy furniture and hardware, place an advertisement in the *Altrincham and Bowdon Guardian*, or if you needed to

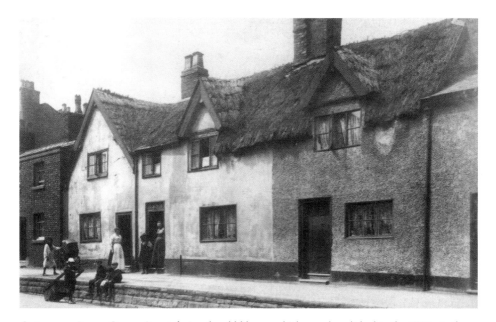

Cottages on Lower George Street, facing the old library, which was demolished in the 1970s. In the mid-nineteenth century there were more houses than shops on George Street, and several vacant lots with no buildings at all. The build up of the shopping area is a continuous process of the second half of the nineteenth century, when railway transport brought prosperity and new residents, and the first heavy industries began to be established at Broadheath.

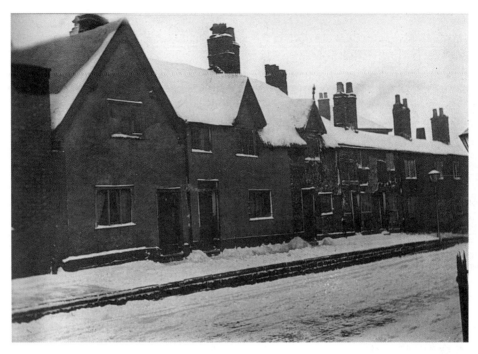

The same cottages on George Street, from a different angle, picturesque in the snow.

reach a wider audience you could arrange to have a larger advert placed all over several towns, by visiting the Altrincham, Bowdon, Sale, and North Cheshire Bill Posting and Advertising Co. Ltd.

More shops had been established on Stamford New Road, where several coal companies had their offices, and the Altrincham Electric Supply Company had installed themselves in the Victoria Buildings, resplendent in shiny red brick and fancy windows. The Downs was much as it is now, with a variety of shops and service industries such as plumbers and painters, and a mixture of physicians and veterinary surgeons. Further up The Downs, the shops ended and the residential area took over, just as it does today. Some notable businesses on The Downs were Miss Florence Graham, photographer, No.31b, in competition with another photography business run by William A. Parsons at No.3. At No.9 there was Charles William Wilkinson, brush and basket dealer, and Henry Flay, portmanteaux dealer at No13.

One of the ways of advertising and stimulating trade is to hold exhibitions and trade fairs. In Altrincham this had long been a prominent feature; Shopping Weeks, Festivals and Christmas Shopping Weeks have been arranged to enable local stores to advertise their wares. These events were usually supported by printed programmes and shopping guides. The organising body responsible for several of the exhibitions was Altrincham and District Traders' Association formed in October 1909 when local shopkeepers acted upon their desire 'to form an organisation of mutual benefit to themselves and the community'. One of their main aims was to formulate their opening hours to provide a reasonable working day for shop workers, and also to satisfy public demand. Some of the problems can be discerned by reading between the lines of the paragraphs accompanying the Shopping Week Handbook and Guide for 1923: 'Possibly some people may think that shops should open at all times, but a very large majority of the community are decidedly in favour of reasonable hours for shops, providing that the wants of the public are supplied in a satisfactory and efficient manner'. About a hundred members enrolled in the Traders' Association

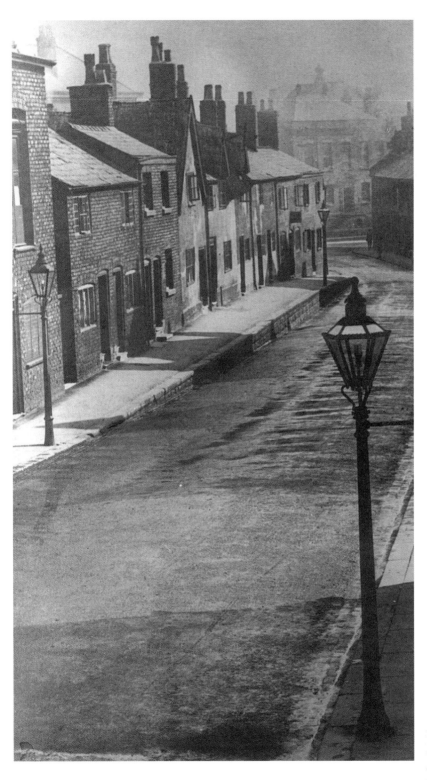

Another view of the
Lower George Street
with the thatched
cottages, opposite the
public library.

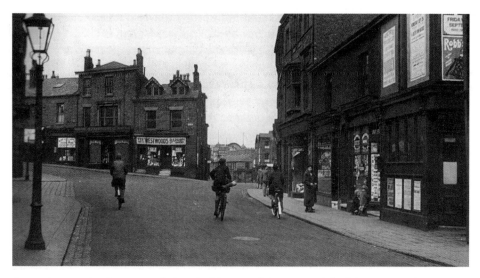

George Street, going down towards Stamford Street and Station Road (both later renamed Kingsway). The arch of the Hippodrome cinema can just be glimpsed in the background.

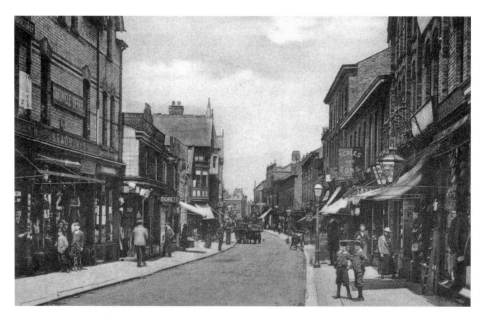

George Street, near what is now the Bricklayer's Arms. As with many of the pubs in Altrincham, the older street directories do not mention the Bricklayer's Arms by name, but in 1852 John Drinkwater occupied the premises, listed as a beerhouse, and owned by William Drinkwater. In 1898 Mrs Mary Drinkwater is listed as beer retailer at No.68 George Street, with Drinkwater's cottages adjoining George Street at this point. By 1901, the pub is listed as the Brickmaker's Arms, not the Bricklayer's Arms, where in 1902 the landlord Joseph Hitchen was prosecuted for permitting drunkenness on his premises on 8 March. In 1898 the shops on the north side of the pub were William Hughes, clothier, at No.60; John Sykes, draper, at 62; Miss Annie Locking, confectioner at 64; Eastmans Ltd, butcher, at 66. On the south side were a photographer, Henry Tierney, at No.70; Thomas Kitchen, a hairdresser at 72; Miss Lena Shaw, confectioner, at 74; Mrs Mary Wood, ladies' outfitter at 76, and a basket and brush warehouse run by Mrs Isabella Brundrett at No.78.

at its first meeting in November 1909, and by the 1920s membership embraced nearly all the shopkeepers of Altrincham, Bowdon, Hale and Timperley.

In a brochure issued for a Local Trade Exhibition held for 7 to 14 December 1929, the preamble defines the objects of the exhibition: 'to bring before the public the fact that the Traders of Altrincham can supply their needs just as cheaply and well as the trader of larger cities . . . It is our aim that the town of Altrincham will benefit generally by this Exhibition, and should we achieve our object, we shall leave happy in the thought that we have done a little good'. Stall No. 1 was occupied by Harry Brown's, of 1 Cross Street, whose advertisement included the information that the shop stocked everything for the wireless – all the latest sets in stock, Mullard, Osram, Cosser. As a recommendation to buy, the advert included the following: Small Boy: 'Daddy, I want some new Meccano for Christmas'. Daddy: 'All right, my boy, we'll go to Harry Brown's. I want a new valve'. The programmes for this 1929 exhibition were numbered, and on each night selected numbers were called out, and those lucky people who held the relevant programme were entitled to buy 10 shillings-worth (50p) of goods in any of the stalls. Some idea of the value of the prizes is indicated by the advertisements where prices were included: 'My Fancy' cigarettes, extra large, 20 for one shilling (5p); a 'Marcel wave' (before the invention of the permanent wave, an innovative process where heated iron tongs curled the hair) at the ladies hairdressers for 20s (£1); a pair of ladies' satin shoes, with high and low heels, 4s 11 ½d, just under 5s (25 pence). So the

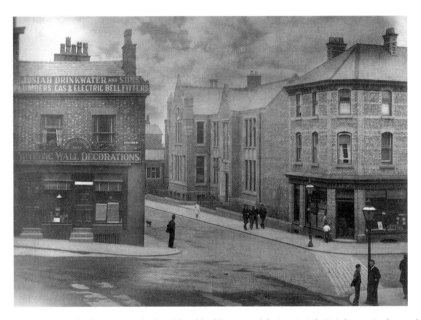

Lower George Street, looking towards the old public library and facing Josiah Drinkwater's shop, which, as the signboard proclaims, was a plumbers, gas and electric bell fitters at 33 Kingsway. Until about 1909, the upper section of the street now known as Kingsway was called Stamford Street, and the lower section was first called Post Office Place, and then Station Road, which was a new road cut through buildings on George Street to join Stamford New Road. Josiah Drinkwater's address until 1908 was 11 Station Road. The firm is listed in the early years as a decorator's business, then as a plumber's and by the time this photograph was taken, Drinkwater's had branched out into gas and electrical fittings. Opposite Drinkwater's on the corner of Lower George Street at No.35 Kingsway is J. Lewis, baker and confectioner, whose address before 1909 was 13 Station Road. In 1901, Lewis's is listed as a baker's shop, then in 1908 as a baker's and corn dealer's, and by 1927 as a hay and straw dealer. By that date No.33 Kingsway, where Drinkwater's used to be, was occupied by Mrs Beatrice Hill, ladies' outfitter.

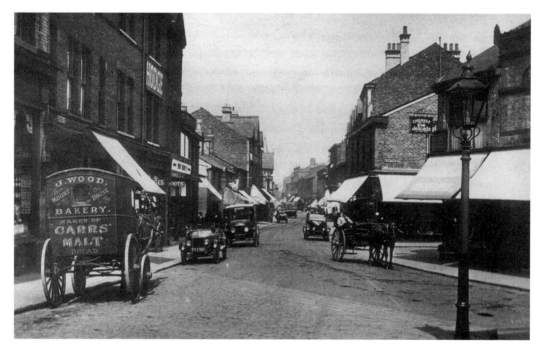

George Street, with the baker's cart outside No.112, Jonathan Wood's grocer's shop, Hodge's bootmaker's shop is at No.106, and opposite at 111 is John Unsworth, chemist.

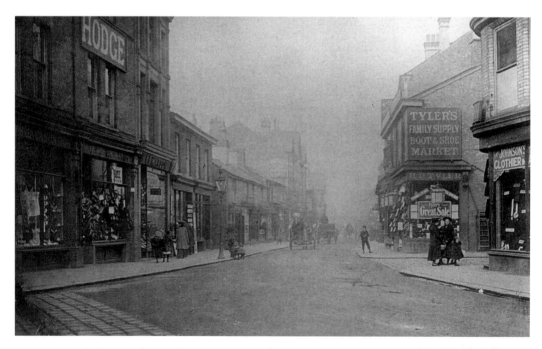

George Street, with another view of Hodge's bootmakers on the left at No.106, documented in 1898 to the 1920s; Tyler's Boot and Shoe market at 109 on the right, was also in operation by 1898 up to at least 1916, but had disappeared by 1927.

prize winners could go home with two pairs of shoes, half a Marcel wave from the hairdressers, or 200 extra large 'My Fancy' cigarettes.

In more recent years, Christmas Shopping Weeks have been organised by Altrincham Chamber of Trade, generally without the benefit of an exhibition, but with advertising supplements published by the local newspapers, accompanied by articles on the problems faced by shopkeepers, on being self-employed, and on the national, political and social developments that affect trade. It was acknowledged in the 1960s that there were serious problems in the town centre of Altrincham, not least the pollution and congestion caused by traffic. The road pattern had been laid out in an era long before motorcars had been invented, and pedestrianisation was seen as the answer to congestion in many towns. The very first experiment in making the street safe for pedestrians by closing them to cars took place in King Street, Norwich, where shopkeepers regarded the prospect with great alarm, because they thought that the trade would decline if people could not park outside their shops. The result was quite different, however, because in general, trade was found to increase in areas where pedestrians could window-shop, wander about, and sit down on benches in what had been the middle of the street, without fear if being mown down by cars. In 1968 a report was issued outlining the proposals for town centre improvement in Altrincham, first analysing the problems, making surveys of current traffic flow and the likely future need for accessibility to the shops by car and on foot. There is a fine balance between people's conditions on one hand, and on the other hand echoing, vast open spaces which are just as detrimental, and the report took this into account, especially concerning the proposals for Market Hall area, where it was stated that although market trade flourishes in areas where space is a little confined, because there is a 'hustle and bustle' effect on shopping that is proven to be beneficial, spaces that are too confined have the opposite effect. In this context in the 1960s, George Street was radically altered, to become

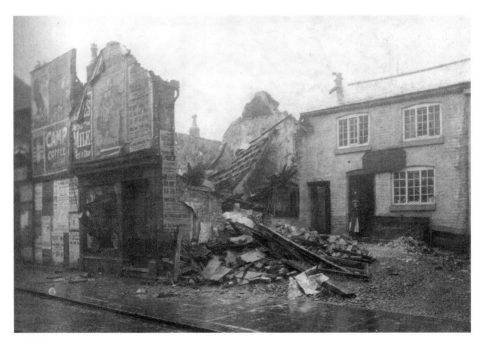

Demolition preceding reconstruction on George Street near Beggar's Square and the Bricklayer's Arms.

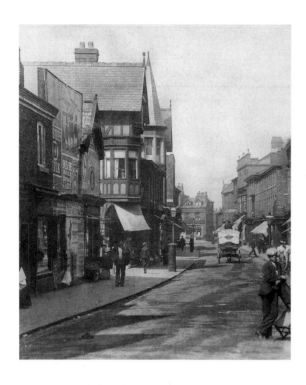

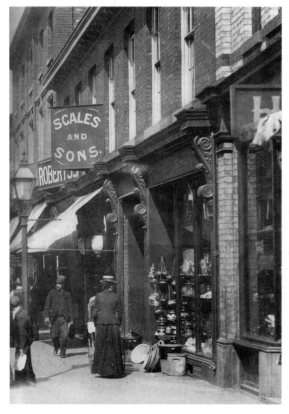

This page: The middle section of George Street, with Beggars' Square and the Bricklayer's Arms hidden on the left, and hoarding to hide an empty space. Scale & Sons on the right at No.91 dealt in boots and shoes. In 1898 the shop was a saddlers, owned by Henry Marsh, and managed by Thomas Botterill, but by 1899 it was empty. Scales were in business by 1901, but by 1905 they had disappeared from George Street, and No.91 was then occupied by a draper's shop run by Edward James Wright. Scales boot shop opened up again at No.1 Railway Street, in a shop that had been Hedges & Co, boot manufacturers.

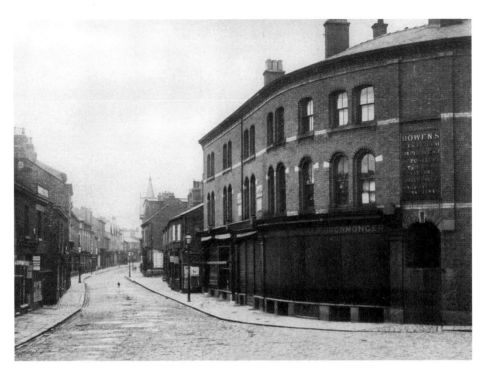

George Street, showing Bowens ironmonger's with its curved frontage, and a signboard saying 'Agricultural implement repository'. George Bowen is listed in the 1864 directory as ironmonger, bell-hanger, tin plate worker, and agricultural implement dealer, at Post Office Place, as the latter end of what eventually became Kingsway was known. By 1898, Bowen's is listed at 26 George Street and Station Road; by 1909, the shop is listed under the executors of George Bowen, with Mark Bowen, householder at the same address. The shop is still listed under Mark Bowen in the 1940s.

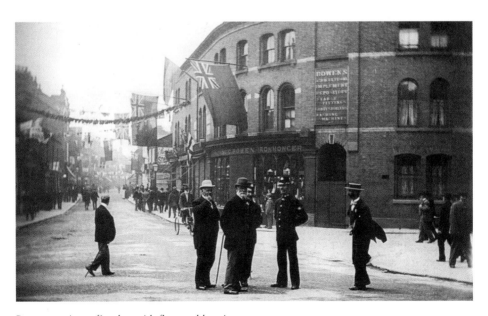

Bowens again on fête day, with flags and bunting.

the pedestrianised shopping centre we know today. The proposals for Stamford New Road, involving the extension of the pavements and the consequent reduction of road area for vehicles, were not carried out.

A shopping survey was carried out in Altrincham in 1985, to find out how often people came to the various shopping centres in Trafford Metropolitan Borough, how they travelled to and from the shops, which town they would visit if they were to buy certain specified household goods, or whether they would prefer to go to Manchester for certain items. The results of this survey were collated in 1986, showing that Altrincham garnered more of the holiday trade than the other towns of Trafford, that the majority of shoppers visited Altrincham for non-food items, or on a lesser scale to combine food shopping with non-food shopping; only one in ten shoppers reported that they had come to Altrincham solely to buy food. By the 1980s Altrincham's primary role in supplying provisions had been overtaken by supply of non-food items, but these figures may now be slightly altered with the appearance in the town centre of the large supermarkets. The 1985 survey also revealed that a smaller percentage of the total numbers of people shopping in Altrincham actually came from the immediate area, compared to Sale or Stretford, where the majority of the shoppers were local. But Altrincham was shown to be the leading town as far as non-local shoppers were concerned.

The trading community in the twenty-first century faces many changes, and schemes for remodelling parts of the town are currently in process. Out of town shopping estates such as those in Broadheath, and, of course the new Trafford Centre, all have an effect on the success or otherwise of the old town centres. Altrincham has been altered, rebuilt, refurbished, remodelled, but even though much has been lost, the town is fortunate to retain much of its old character and all of its vitality as a shopping centre.

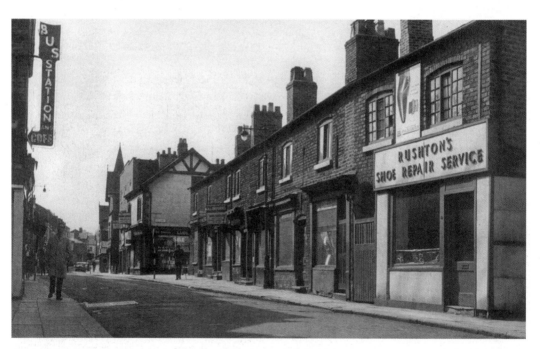

George Street between High Street and Kingsway, looking in the direction of Regent Road, with a sign pointing to the bus station on the left.

George Street in the 1960s before pedestrianisation.

Another view of the congestion on George Street before pedestrianisation.

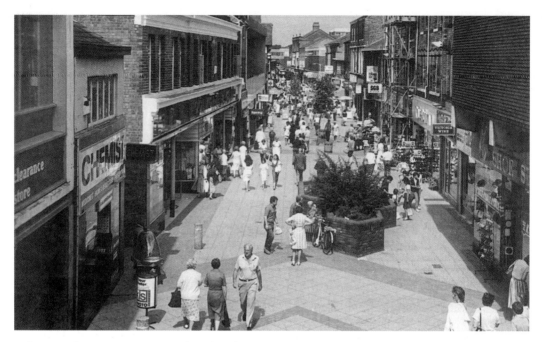

Pedestrianised George Street near Woolworth's. The new layout makes shopping a more leisurely and less fraught experience, without the need to squeeze onto the narrow pavements to avoid cars and vans.

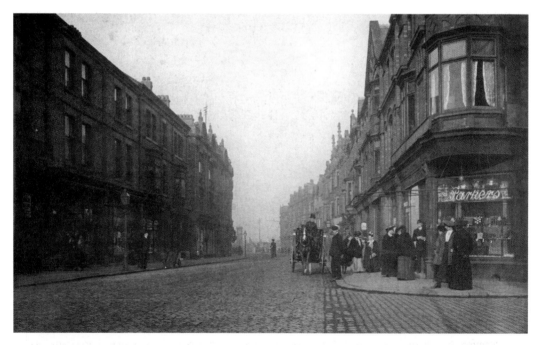

Stamford New Road, looking towards the railway station, with Eustace Parker's jewellers and watchmakers on the corner of Grafton Street. Parker's was already in business at the end of the nineteenth century. On the opposite side of Grafton Street, just off the right-hand side of this photo, was J.B. Wilson & Son. Oriental bazaar.

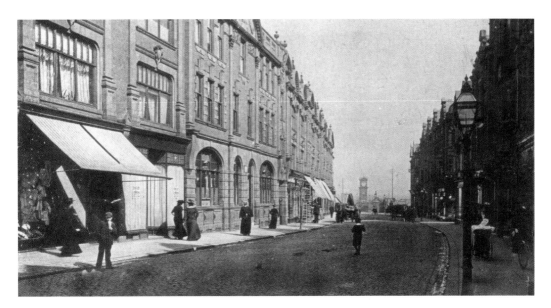

A different view of Stamford New Road, looking in the same direction, nearer to the Post Office block is shown as a vacant lot. Old maps show in 1874 that the main Post Office was on George Street, almost facing Bowen's ironmonger's, before the road was cut through to the north of it, to join Stamford New Road. The Post Office moved to Market Street until 1900, and moved once again to its present location between 1900 and 1901.

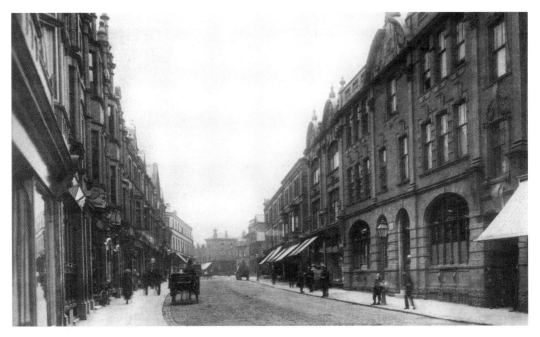

Stamford New Road looking towards Bowdon. Note the road surface made up of square stone setts. The fact that no tramlines are visible indicates that the photograph was taken before the tram service was established in 1907.

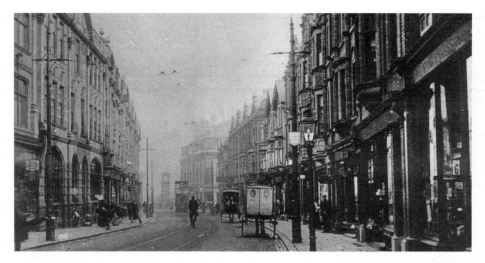

Stamford New Road with tram, bicycle and horse-drawn vehicles. In contrast to the previous photographs, the presence of trams in this picture indicates that it was taken some time after 1907. Station Buildings, just visible in the distance, were built between 1907 and 1908; compare the previous photos looking in this direction but taken at earlier dates, where it can be seen that there is an open space just before the railway station. The shops on the right-hand side of the road c. 1907–8 included J. Bradbury and Co., wine and spirit merchants, Miss Clara Hildage, wool and fancy repository, A.H. Burgess, chemist, Taylor & Cross, hosiers at nos 31 and 33, the Altrincham Electric Supply Company, which later moved to premises on the opposite side of the road in the Post Office block, Lipton's grocery store, and Clibrans florists.

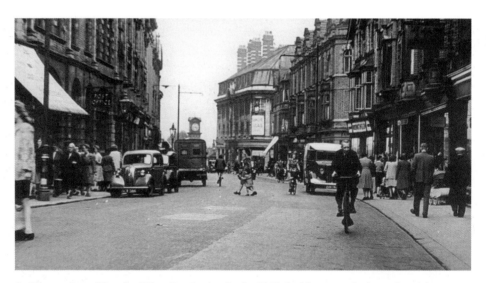

A different view of Stamford New Road, taken in the 1950s looking towards the station. A large advertisement on the corner of the Station Buildings proclaims Blanche Lucas Limited. In the block on the right-hand side, just before Station Buildings, are located the Scotch Wool Shop, now the Edinburgh Wool Shop, and W. H. Smith & Son, bookseller's. Smith's was originally established near the railway station until 1907, when Wyman & Sons took over the station bookshop and newsagents. W. H. Smith's moved to 17 Stamford New Road, with John Leytham as the manager, in 1907; the premises were occupied by Robert Scott, optician in 1905, and were vacant in 1906.

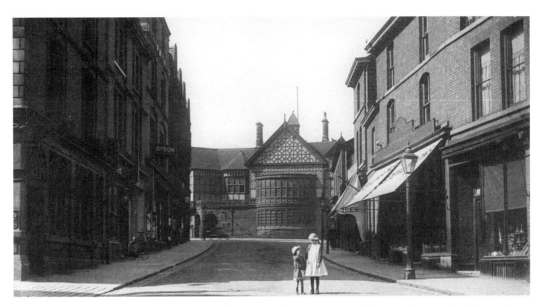

Kingsway, looking towards the Old Market Place. The upper portion of this road, where this photograph was taken, was originally called Stamford Street until about 1909, the lower half being named Station Road. The sign on the left advertises John W. Byrom's drapery store, which was an old established business, set up before 1898 and surviving at least until the 1960s. Its original address was 4 Stamford Street, changing in 1908 or 1909 to No.10 Kingsway. By 1911, the store had expanded, taking over No.8 Kingsway as well, and had branched out from the drapery business to include the sale of hats.

Another view of Kingsway, with Elizabeth Chantler's premises on the left at No.32. This was another old established business, recorded at the end of the nineteenth century, originally on Station Road before the road names were changed and Kingsway came into being. It is listed as an outfitter and baby carriage manufacturing company. For a brief period at the same address there was a coachbuilder, Fred Pickston.

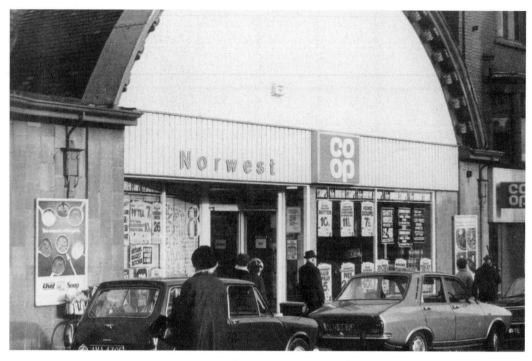

Norwest Co-op on Kingsway, pictured in November 1973.

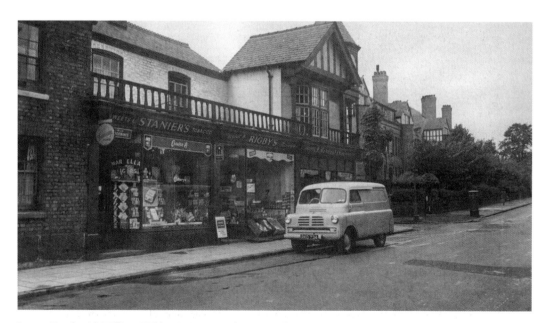

Regent Road, with William Walden Stainer's confectionery shop at No.33. Stainer took over from Frederick Bennett, who was also a confectioner. In the 1920s and 1930s Rigby's shop was occupied by Bowland & Sons, decorators.

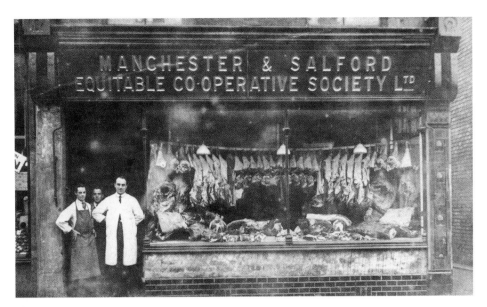

On the corner of Devonshire Road and Manchester Road, the Manchester and Salford Equitable Co-operative Society. This shop was established before the end of the nineteenth century. The early street directories simply gave a list of the shops between Devonshire Road and Woodfield Road, without Street numbers. When numbers were allocated to the premises on Manchester Road, this shop was listed at 71 and 73. In 1916 the manager was Joseph Wood; in 1927 no manager is recorded, and No.73a is occupied by Frank Worthington, driver, who perhaps lived in an upstairs apartment.

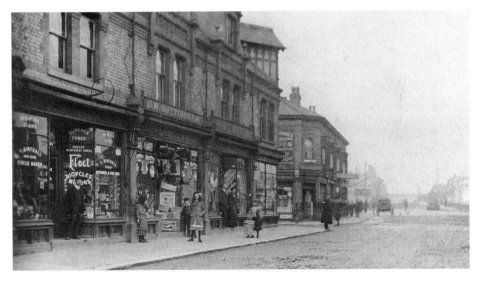

Manchester Road looking towards Timperley. The signs over the shop doorways read Birchall and Nottingham. When street numbers had finally been allocated, Thomas Birchall is listed from about 1905 as a bicycle agent at No.91; by 1916 the premises had been taken over by James Potter, who ran a butcher's shop. George W. Nottingham, provision dealer, is also listed from about 1905. By the 1920s the provision store was run by Julian and Buckley.

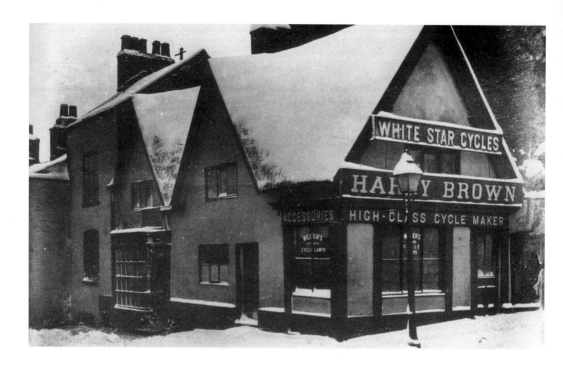

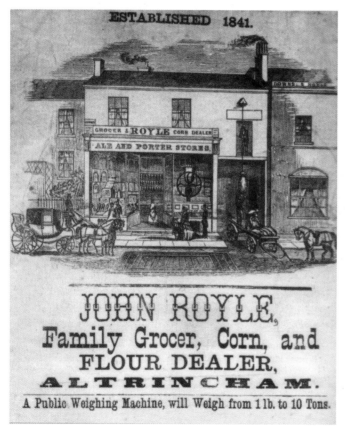

Above: Harry Brown's cycle shop in the Old Market Place. This business was established here by 1903, and remained there until about 1912. Harry Brown also had a workshop at 45a Church Street, and another shop in Hale.

Left: Advertisement for John Royle, grocer, corn dealer, ale and porter supplier. The business was set up in 1841 at 2 The Downs. In a directory for 1864, the entry says that Royle's dealt in groceries, British Wine, ale and porter, and was also a corn merchant's. Also listed at No.2 is The Downs Hotel, run by Samuel Royle, who was 'licensed to let horses'. Both John and Samuel Royle are recorded in the directories for 1848 and 1855 under the headings for grocery stores and for inns. Thirty years later there is no mention of John Royle's shop, and by 1898 the address of The Downs Hotel had changed to 44 Railway Street.

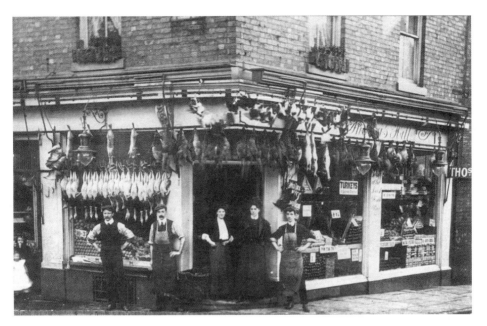

Hill's poulterers, on the corner of George Street and Regent Road. The address is 123 George Street, and this shop was occupied at the beginning of the twentieth century by Beresford and Furness, butchers. In 1902 the shop was run by James Furness alone, without Beresford, then in 1903 Thomas Hill took over, selling poultry, fish and fruit. Hill's was taken over sometime before 1927 by Allendale Ltd, fruiterers.

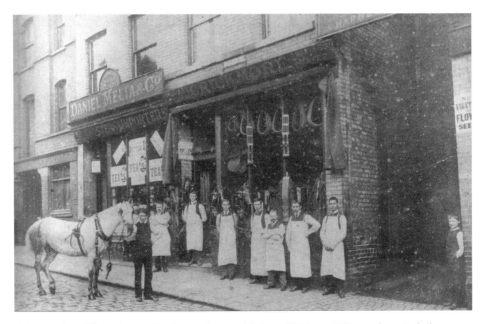

Crickmore's saddler's shop at 116 George Street, with Daniel Melia at 118 next door. Both these businesses can be traced back to the nineteenth century. Crickmore's survived until at least 1942, but Melia's moved from 118 George Street to No.80, on the same side but further along, probably before 1927, when No.118 appears to have been empty. By 1939 the shop was occupied by F.S. Thompson, linoleum dealers.

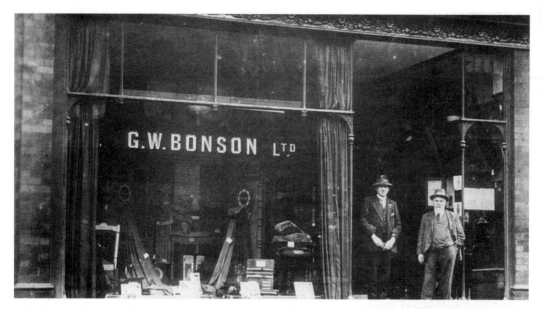

G.W. Bonson Ltd was owned by Godfrey William Bonson, cabinet-maker, at 11 Stamford New Road, and Bonson's is listed at No.13.

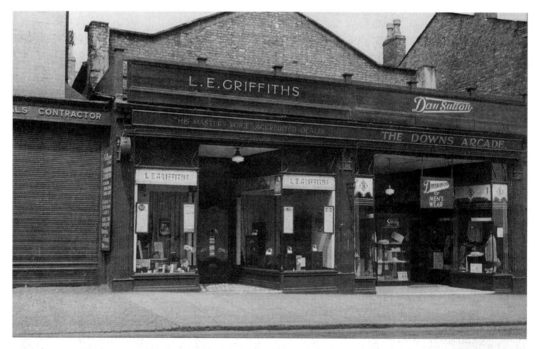

L.E. Griffiths and Dan Sutton, The Downs Arcade, nos 12 and 14, The Downs. Mrs Lily Elizabeth Griffiths, wireless dealer, is listed in 1939 at No.14. In 1927 the shop at No.12, eventually taken over by Sutton's gents' outfitters, was a photographer's premises, run by William A. Parsons.

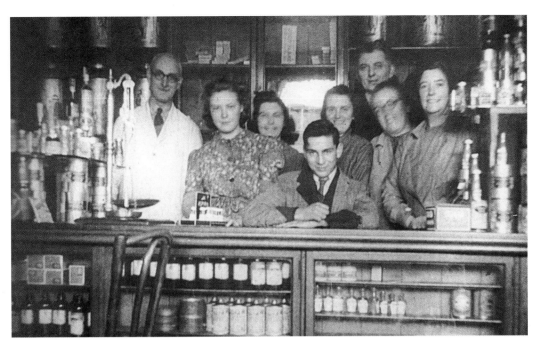

Interior of Burston & Nixson's grocery store.

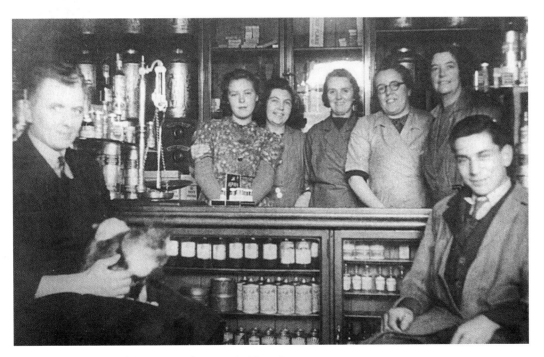

A different view of the interior of Burston & Nixson's grocery store.

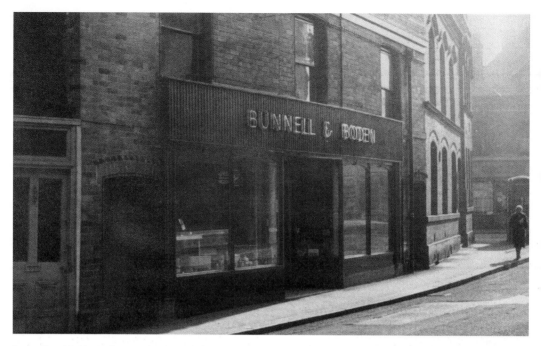

Bunnell and Boden's shop on the corner of George Street and Stamford New Road. W. Bunnell started a business as a cycle agent on Stockport Road, also selling car accessories; an advertisement in 1934 says 'workmanship guaranteed'. At the end of the 1930s Norman Boden had a bicycle shop at 5 and 7a Regent Road, and also at 2 Acacia Avenue, Hale.

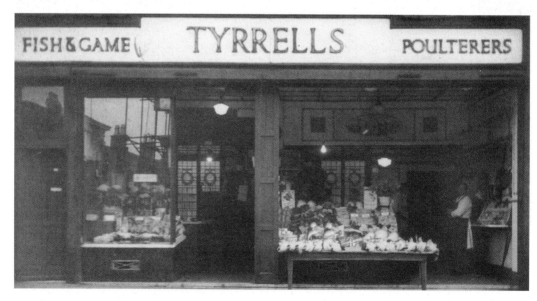

Tyrrell's fishmonger's and poulterers shop, at 8 Ashley Road, was established by 1909. The shop was occupied by a hairdresser, Samuel Hulme, in 1901, then by 1903 Stephen Wrathall took over, selling fruit and fish. He was followed by A. and M. Fletcher, fruiterer's and fishmonger's who had arrived by 1906. The shop was vacant in 1908, until Mrs Elizabeth Tyrrell took over. The shop survived until the mid-1990s, and is now occupied by Helgason's chemist's shop.

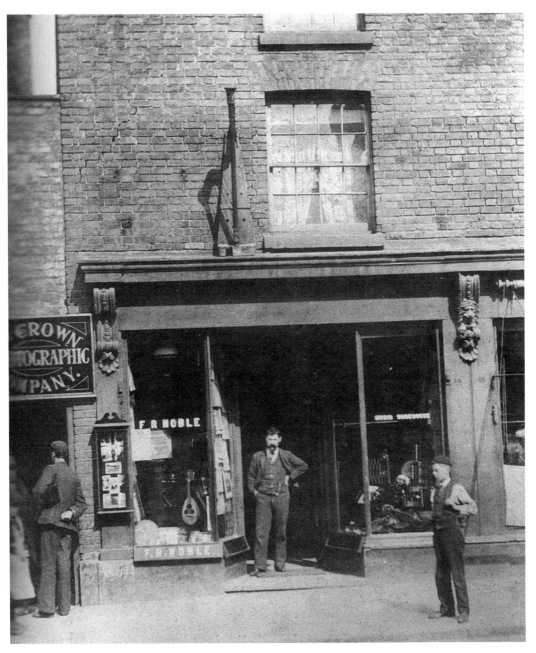

F.R. Noble, and the Crown Photographic Company at 19 Railway Street, c.1900. Noble's sold musical instruments from this shop from about 1890 to 1903, when the business expanded and moved to 47 and 53-55 George Street. The photographer's premises at the same address on Railway Street was occupied by a succession of different photographers; from 1898 to 1904, William Peters ran the business, followed by Miss Ada M. Cavill from 1905 to 1907.

Chapter 3
Getting About

It is an obvious fact, but one that needs underlining, that for centuries in any town the only way of moving about was by 'Shank's pony', that is on foot, or on horseback, or by horse-drawn vehicle. The transport revolution is a comparatively recent development, and its origins lie in the types of horse-drawn vehicles that served the population until motorised transport replaced them. The canals were hailed as a revolutionary concept, but the boats were still drawn by horses plodding on the towpaths. Even the first railway carriages were designed like horse-drawn stagecoaches, all linked together, because no one had any experience of building any other type of vehicle. The designs were gradually altered as manufacturers became more used to building long coaches.

The canal system was established in the second half of the eighteenth century, predating the railways, trams and buses, and revolutionising the transport of heavy goods. The roads in the eighteenth century were sometimes little more than quagmires in wet weather and full of ruts and banks of earth in dry weather. On horseback, the problems were lessened, but carting heavy goods was a nightmarish business. On the canals, however, goods and people could be carried smoothly, rapidly, and profitably. Factories and businesses grew up alongside the canals, where the raw materials could be brought in, and finished goods could be distributed. Before the canals were established there had been various schemes to make rivers navigable, by straightening out loops and bends, and sometimes cutting artificial channels, which were lined with stone. These navigable ways always depended upon the rivers – until Francis Egerton, third Duke of Bridgewater, decided to build a completely artificial channel, initially from Worsley to Manchester, to carry coal from his mines. The canal was soon extended. The first sections of the Bridgewater Canal running from Worsley received the royal assent 23 March 1759, and the first boats were operating by the second half of 1761. The sections that ran through Broadheath, Dunham and Lymm were built a few years later. An Act of Parliament was passed in 1762 authorising the Duke of Bridgewater to 'make, complete and maintain a navigable Cut or Canal, passable for boats, barges, and other vessels, at all times and seasons, from or near Longford Bridge...over the River Mersey and through several townships of Altringham (sic), Dunham... Lym (sic) and Thelwall, in the county of Chester, and to or near a certain place called the Hemp Stones, in or near the township of Halton'.

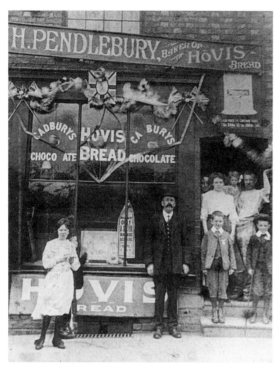

Left: W. H. Pendlebury's baker's shop 22 Lloyd Street. This photograph was taken on the day of the procession to mark the Coronation of George V, 22 June 1911. The bakery was established at the end of the nineteenth century, and is attested in street directories until 1915. In 1914, 22a was occupied by Lee Sing's laundry.

Below: Coach and horse outside The Downs Hotel, photographed c.1860, when photography was only about two decades old. The ghost-like images in the foreground and at the left-hand side of the pub indicate a long exposure time during which people moved about. Commendably, the horse must have kept quite still.

Opposite above: The 'Tally Ho' Four-horse stagecoach that ran between Altrincham and Delamere, photographed outside the Abbey Arms at Delamere and presumably ready to take the passengers to Altrincham. The resemblance to the Wells Fargo stagecoaches in western films perhaps ends with the various styles of hat and the lack of a shotgun rider.

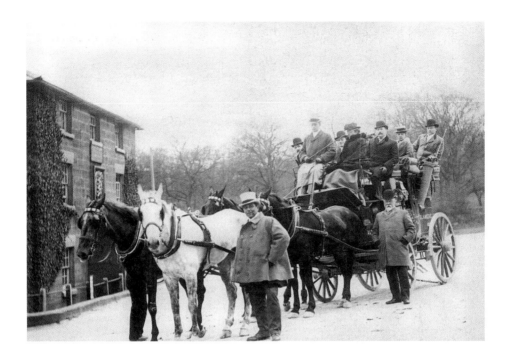

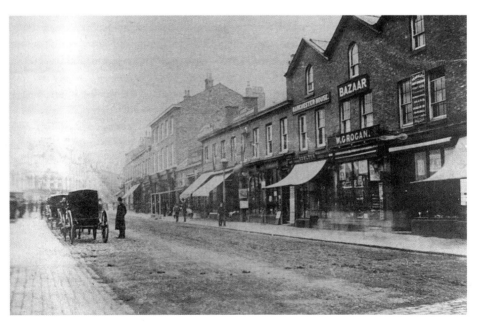

Horse-drawn cabs lines up on Railway Street, before the building of the present railway station on Stamford New Road. Horse transport was not made redundant when trains and trams were established, because people still needed to get to and from the stations and tram termini. These cabmen are waiting for passengers alighting from trains at the Bowdon Terminus, which was situated between Railway Street and Lloyd Street. Just off the photograph there was a hotel fronted by a garden, leading on to the platforms of the terminus station. All this was demolished when the new station was built, but the name Railway Street remained, as the only trace of the once flourishing Bowdon Terminus.

The Act covered every occasion and circumstance that canal builders could possibly meet with. It allowed the duke to cut trenches, remove earth and rubble, and construct bridges, piers, and arches across the River Mersey, 'between the said Longford Bridge and Altringham'. The goods carried on the barges were subject to tolls, up to a maximum of two shillings and sixpence for every ton of coal, stone, timber and other goods. The canal was open to traffic to and from Broadheath by 1775. The boats could carry goods and passengers to and from Manchester, and soon provided transport for the produce of the farms around Altrincham, to be sold at the Manchester markets. In 1861, the Bridgewater Trustees advertised 'conveyance by water to London and all parts of England from the Wharf, Broadheath, daily'. Packet boats ran to Manchester in one direction, and to Liverpool and Runcorn every day in the summer, starting from Altrincham Bridge, and calling at Lymm. Every evening boats ran to Stockton Heath near Warrington.

Fortunately for historians, the rise of photography from the 1840s encompassed the latter days of the canals and horse-drawn transport, and the beginning and gradual development of trams, railways and motorcars and buses. Motorised transport facilitated the carriage of large numbers of people, which was simply not possible in the days of horse transport. There was an upper limit to the number of passages that could be carried in stagecoaches or horse buses, even if the vehicles were pulled by teams of four, or more rarely six horses. The range for horse-drawn vehicles was also limited, and unless relays of fresh horses were set up at points along the routes, long journeys could not be contemplated. For transport in and around the towns, though the journeys were not long in terms of miles, there was still a need for relays because the horses could not be expected to work long hours without tiring to the point of exhaustion. Spare horses were also necessary for places where the terrain was difficult. The Altrincham area is not noted for very steep hills, but in towns where there were sharp inclines, spare horses were often stationed at the foot of the hill just to help pull the vehicles up, then the extra horses went back downhill to await the next vehicles.

There were various coaches and carriers who operated from Altrincham at the beginning of the nineteenth century. In the 1820s travellers could go from Altrincham to Chester every day, by picking up the Victory coach at 7 o'clock in the morning, outside the appropriately named Wagon and Horses tavern. Alternatively, at 7 o'clock in the evening, passengers could set off from the same location to go to Manchester. Another route to Chester was by the Pilot coach from the Navigation Inn at half past two in the afternoon, returning the next day to Manchester at the same time. This coach would provide a service for the passengers who had travelled via the Bridgewater Canal and alighted at the Navigation Inn. On three days each week, Thomas Lilley ferried goods between Manchester and Northwich, via Altrincham, and John Warburton made the same journey via Bowdon, also on three days a week.

For short-range transport, horse buses became more common from the 1830s. The institution of two decks increased the number of people that could be carried, but the journeys were uncomfortable by today's standards. Conditions were cramped and cold; there was no heating in the lower decks and the top decks were open to the weather. Jolting was severe enough in some cases to result in great bruises on arms and legs, sometimes even fractures. Horse buses still operated when the railway had been established, and worked in close conjunction with the train service. In 1861, under the heading of 'conveyance by railway', it was advertised that 'omnibuses leave the Bowdon Railway Station for Knutsford and Northwich at ten minutes past eight and a quarter before twelve in the morning, and a quarter before three and a quarter before seven in the evening'. Bowdon station no longer exists, but in 1861 the railway lines extended further into Altrincham, ending at Bowdon Terminus, in the corner of land between Railway Street and Lloyd Street.

The introduction of horse trams improved conditions in that the tracks obviously had to be level, and the ride was much more smooth. In the Manchester area, horse trams first appeared in the

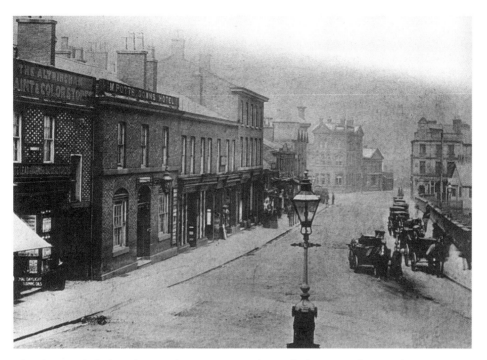

This photograph, looking down Railway Street towards Stamford New Road, gives a better indication of the hotel and walled gardens at Bowdon Terminus, though all that can be seen is the outer wall of the garden. The cabs line up like modern taxis awaiting customers.

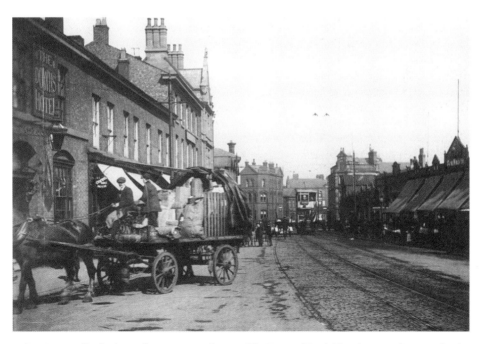

Delivering supplies by horse-drawn cart, perhaps to The Downs Hotel. The photographer was clearly not interested in the horse.

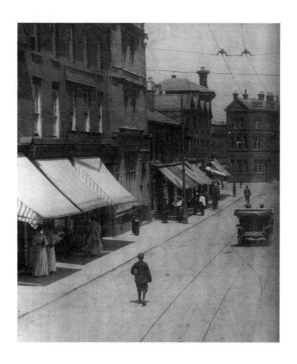

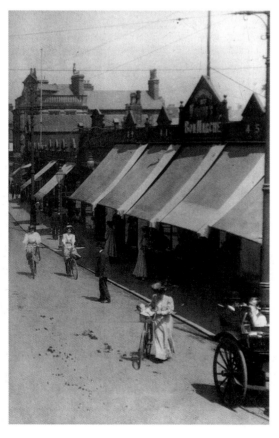

This page: Railway Street in the early twentieth century where horses still hold their own in the new era of the tram and the motorcar. Bicycles were also popular, judging from the ladies moving towards the camera.

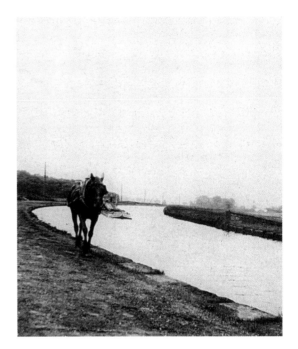

The Bridgewater Canal revolutionised transport in the second half of the eighteenth century, enabling heavy goods to be carried quickly and cheaply. Until the arrival of steam-powered barges, the pulling power was provided by horses, as shown in this photograph of the Bridgewater taken somewhere near Altrincham.

late 1870s, and lasted for about three decades, well into and overlapping the era of the powered trams. The design of the horse trams had some bearing on the designs of the later powered ones, and was principally dictated by the need to turn the whole car round at the terminus to face the opposite direction. With single-ended trams there was usually a turntable, but with double-ended vehicles, the horses were unhitched when they reached the terminus, and simply walked round to the opposite end to be hitched up again. There would be many more horse teams in service than tramcars, because the shift system meant that three or four teams would be needed to run the services from morning till night, and then there would be sick and lame animals in recovery. It was generally reckoned that the ratio should be eleven horses to one tramcar. This meant that there would be extra staff to look after the stables and to attend to the horses once they came off duty, since unlike modern buses and cars, once the horses are 'parked' for the night, or at the ends of their shifts, someone still has to groom and feed the animals. The advantages of horse transport over motorised transport are that pollution by noxious gas is eliminated, and the exhaust products of horses, so to speak, could be gathered up and sold as fertiliser. While a car is at traffic lights, it still uses and burns fuel, but while a horse stands still, it is having a rest.

Powered trams took over from horse trams in several towns in the 1870s. There had been a brief experiment with steam-powered trams in Manchester in the 1860s, in the city itself, and in Bury, Rochdale and Oldham. At the same time, electric power was harnessed to drive the trams; Brikenhead was the first town in the north-west to establish electric-powered tram routes in 1860. A general Tramways Act was passed in 1870, authorising local councils to establish and maintain electric tramways, but not to operate them. The operational side of the business was thrashed out later, and the first tramway in Manchester was laid down in 1875. Lines were soon extended to the suburbs. On 16 August 1900, an agreement was made between Manchester and Stretford Urban District to take over the old horse tramlines. The electric powered tram service reached Sale in 1906, and the lines were extended to Altrincham in 1907. In c. 1904 when tramways were proposed for Altrincham, and routes were being planned, a leaflet outlining the proposals

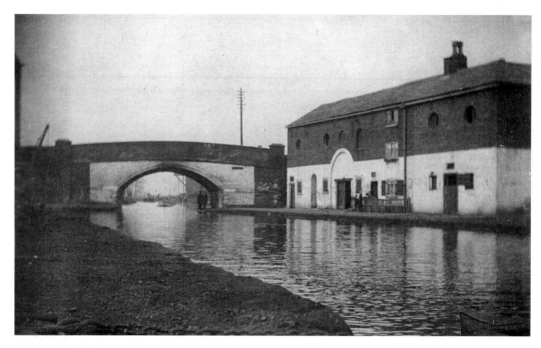

A major part of the construction of the canal was the building of bridges to carry roads across it. This is the old Altrincham Bridge at Broadheath, also called Manchester Road Bridge.

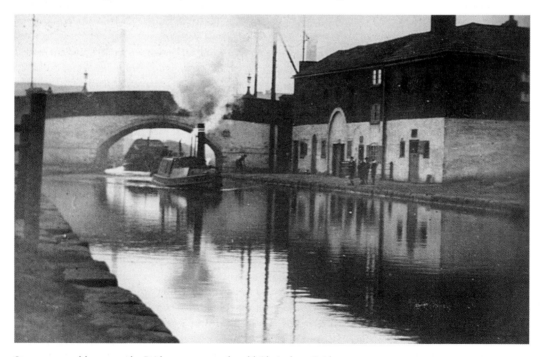

Steam powered barge on the Bridgewater, near the old Altrincham Bridge.

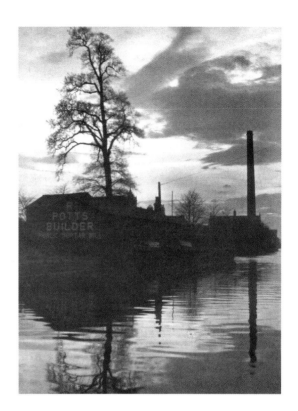

The Bridgewater near Altrincham Bridge, photographed in 1933. Factory chimneys and warehouses made picturesque at sunset.

stated that 'The Cars proposed are small single deck ones, the ends partly open, and the centre portion closed. The service would be regular and punctual all year round, averaging probably twenty-minute intervals. The fares would be in Penny Stages of about One Mile, but possibly Half-penny Stages might be adopted for certain parts. Arrangements might also be made in the scheme for Public Lighting'. As the photographs show, the tramcars were not limited to single deck when the line was finally opened. A booklet published in 1924 lists tram nos 47 and 48 from St Mary's Gate, Manchester, running every eight minutes to Altrincham, with the last tram leaving at 10.35pm. The journey took on average one hour and the fare was sixpence halfpenny, or fivepence halfpenny to Broadheath. In the introduction to the booklet it is stated that the tram journeys in and around Manchester were the 'nearest thing to a Motor Tour that can be imagined, and is quite health giving and invigorating'. The writer of the booklet also claimed that tram rides provided much of interest 'especially the different shades of dialect spoken on the journey'. Manchester Corporation Tramways had offices all over the Manchester area, with the head office at 55 Picadilly, Manchester. The Altrincham office was at 2 The Downs, and the tram terminus was situated where the Downs meets Railway Street.

The name Railway Street is now a slight misnomer, since there is no trace of any railway nearby. As mentioned previously, the present railway station is on Stamford New Road, but in the early days of the steam railway the first terminus was on Stockport Road, but very quickly superseded by a new terminus on Railway Street. The railway lines came down as far as Lloyd Street, at the Bowdon Terminus. The large-scale map of Altrincham issued by the Ordnance Survey in 1876 (sheet XVIII 6.2) shows in great detail where the terminus was, oriented on a line running south-west to north-east. There were carriage sheds to the north of Goose Green, roughly where the present station ends, and at the opposite side of the terminus there was a turntable on the corner of

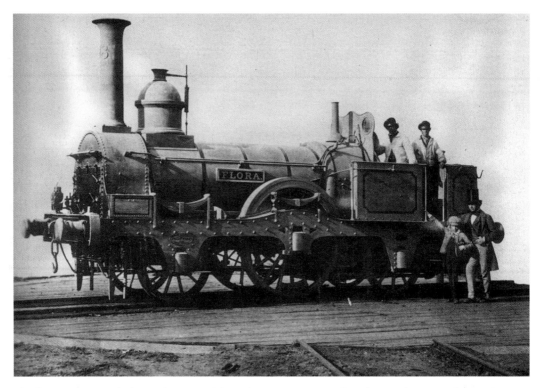

This famous photograph shows *Flora*, one of the early steam engines used on the Manchester South Junction and Altrincham line.

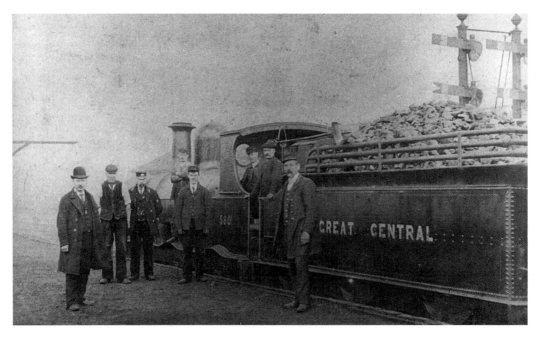

Steam train at Altrincham station, the tender loaded with coal.

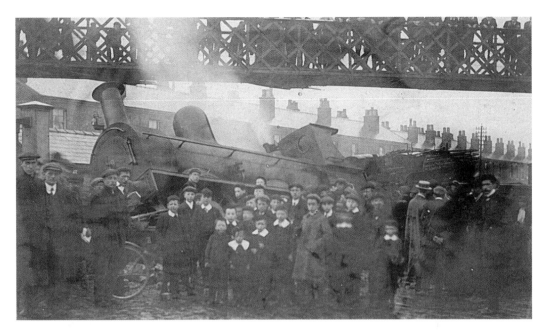

A derailment at an unknown date, perhaps c.1910, near Navigation Road. Filed with the photograph is a letter from Mr W.G. Gulliver, who writes that an accident occurred on a Sunday morning, when the train left the rails and headed into the gardens of houses opposite the line. Mr Gulliver stated that 'the train was running free on the down gradient from Hale, signals off and clear, and for some reason unknown, the train was turned into the loop while the signals were off for the main line'. The driver and the foreman escaped without serious injury, and were not blamed for the accident.

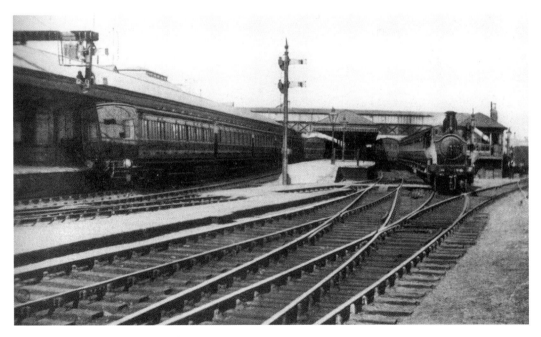

The station at Altrincham with steam trains.

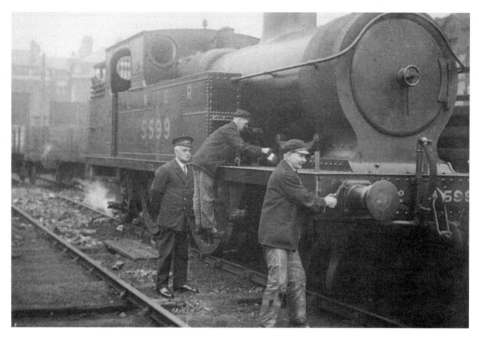

The last steam train to run from Altrincham to Manchester was the LNER No.5599, in 1931. Photograph by E.J. Horley of Altrincham.

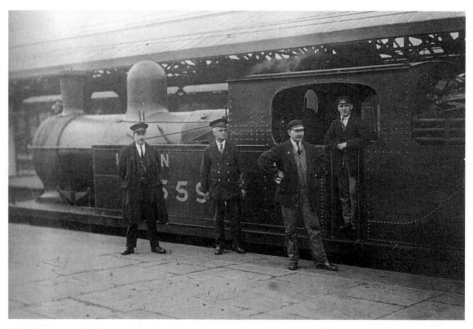

LNER 5599 at Altrincham station in 1931. The names of the personnel standing with the engine are written on the back of the photograph. From left to right they are Ticket Inspector Bill Jackson, Inspector William Armstrong Leigh, Driver Charles Dean, and Fireman Bob Barnett. Photography E.J. Horley of Altrincham.

Railway Street and Lloyd Street where the engines were turned around. The map shows the parcel office, the waiting rooms, and the platform, and attached to the station was a hotel, fronted by a walled garden, which flanked the south side of Goose Green. By 1881, the main station was built on its present site, and the 1898 Ordnance Survey map shows that Bowdon Terminus had been converted into carriage sheds. The hotel had been demolished, and a row of shops had been built on the east side of Railway Street, where demolition is lately going on prior to rebuilding.

The development of railways in Manchester began in 1830, when the Liverpool and Manchester Railway was opened. It was a successful enterprise and boosted the establishment of railways all over the country. Within ten to fifteen years, there were five more railways running into and out of Manchester, but they all came into different terminus stations, with the exception of two lines, which shared a terminus. There were at first no links between various stations, which meant that passengers travelling through the city had to walk and carry their luggage to the relevant station to begin the next stage of their journeys. When Victoria Station was built to connect three of these lines, the two companies that were left isolated built the Manchester South Junction line to link them with the Liverpool and Manchester Railway. A branch of this line was planned to serve Altrincham and the towns between there and Manchester.

This new railway would compete with the transport already provided by Bridgewater Canal. Fortunately one of the main trustees of Bridgewater was Francis Lord Egerton, who also owned much of the land in the Altrincham area. When agreement had been reached over the establishment of the railway, which became known as Manchester South Junction and Altrincham Railway, an Act of Parliament was necessary to authorise the purchase of land and the building of the lines. In July 1845 the Royal assent was granted, and 'The Manchester South Junction and Altrincham Railway Act' was

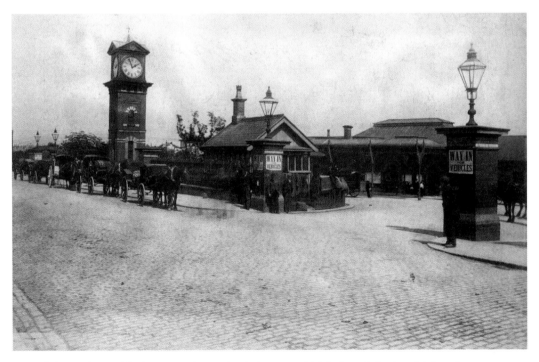

Cabs waiting outside the new station at the clock tower, which is the only landmark left at the present Altrincham interchange.

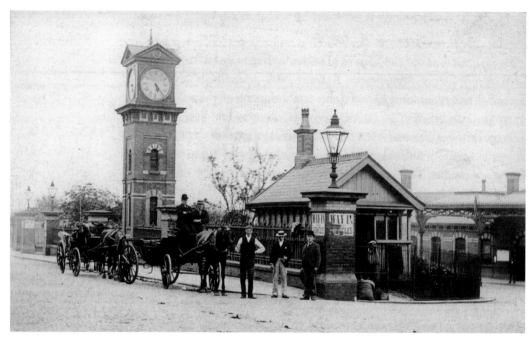

A slightly different view of the station with cabs waiting outside, but the photograph must have been taken at a later date than the previous photograph, since the notices proclaiming the way in for vehicles have begun to peel off.

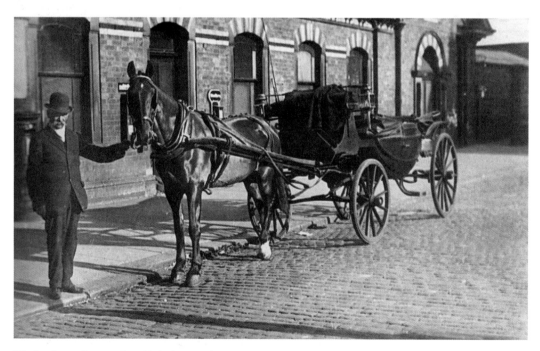

The last horse-drawn cab at Altrincham station.

passed, the Act took expenditure into account: 'the estimated expense of making the said railway and works amount to the sum of four hundred thousand pounds; be it enacted that four hundred thousand pounds shall be the capital of the company'. There followed regulations for the apportionment of shares, and for the raising of loans. The contract for building the railway was won by John Brogden of Sale, in October 1845. Brogden was an important man with influence in the town of Sale, and must have suddenly changed his mind about the railway, since only a few months earlier he had signed a declaration along with other business men and landowners in Sale, to the effect that they opposed the establishment of the railway because they felt it would be injurious to the town. Even after the Act was passed and the contract for the building had been signed, there were frustrating delays of one kind and another, involving difficulties over the purchase of necessary land, and shortage of cash. Work began in 1846 after the land was purchased, but ground to a halt in 1847; however by 1849, the line was ready. The first steam train to Altrincham left Manchester on 28 May 1849, carrying invited guests who alighted at Altrincham and went for refreshments at the Unicorn Hotel.

After the success of Manchester South Junction and Altrincham venture, railways began to multiply in the area. In order to provide for passengers and goods travelling to the west and into Cheshire, another railway was planned to connect Altrincham to Knutsford and then to Northwich. 'An Act for making a Railway from Altrincham through Knutsford to Northwich in the County of Cheshire, and for other purposes', or the Cheshire Midland Railway Act as it was

Broadheath and Timperley were once well served with railways, although little remains of the LNWR and the Cheshire Lines Railway that used to serve the area. All the lines, including the Manchester South Junction and Altrincham Railway, met and crossed just east of the Bridgewater Canal, around the present Deansgate Lane and Newstead Terrace.

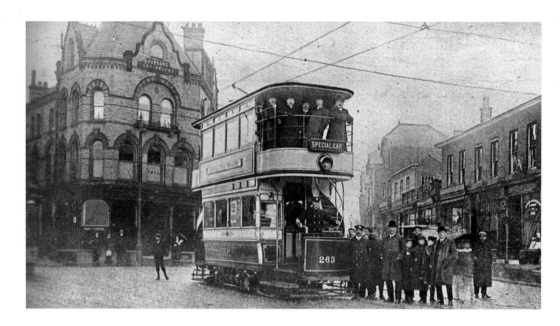

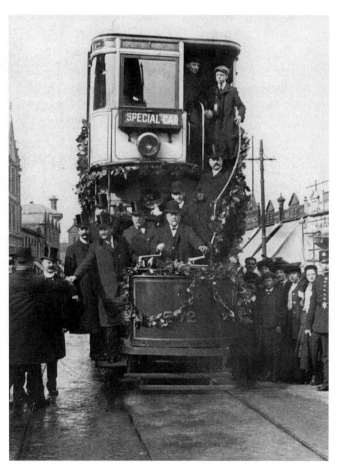

Above: Electric-powered tram services from Manchester and Stretford reached Sale by 1906, and Altrincham by the following year. The first trial run took place on 30 April 1907, from Manchester to the terminus at the junction of Railway Street with The Downs and Ashley Road. This photograph shows the Special Car No.263, with dignitaries aboard.

Left: The passengers service on the electric trams was opened on 9 May 1907. This photograph shows Special Car No.592, garlanded and fêted as it arrived at the terminus.

known, was passed in June 1860, and the line opened from Altrincham to Knutsford on 12 May 1862. Stockport, Timperley and Altrincham Junction Railway was incorporated by an Act of 22 July 1861 and empowered to construct a line from the Stockpoprt and Woodley Junction Railway to connect with the LNWR at Broadheath Junction. This was opened 1 February 1866. The connection with Manchester South Junction and Altrincham Railway at Timperley junction was not constructed until 1878, and opened on 1 December 1879. The Warrington and Stockport line, opened in 1853, catered for east-west traffic, and there were stations at Broadheath (stationmaster John Hargreaves) and Dunham (stationmasters Charles Holgate and John Amilton).

By 1899 the Manchester South Junction and Altrincham Railway was carrying five million passengers per year. The growth of the railway service made a tremendous impact on the small towns on the route, such as Sale and Altrincham. More and more people could now afford to commute to and from Manchester. The mill owners and business men who lived in the city and worked at their various establishments migrated into the calmer rural areas and built houses in Altrincham and Dunham; this movement has been documented by Frank Bamford in his book, *Men and Mansions of Dunham Massey*. As the population expanded in Sale, Timperley and Altrincham, the spin-off for small shops and the market traders improved business, and more housing was built, shaping the towns that we know today. The social and commercial influence on Altrincham of all forms of transport, but principally the railway, cannot be overestimated.

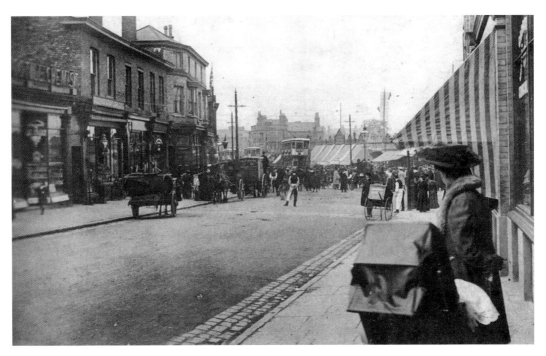

This photograph shows the crowd that gathered to greet the arrival of the first passenger tram at the terminus in May 1907, viewed from The Downs. Tootill's Chemist shop can be seen at the single storey building on the left of the picture, at No.12 The Downs.

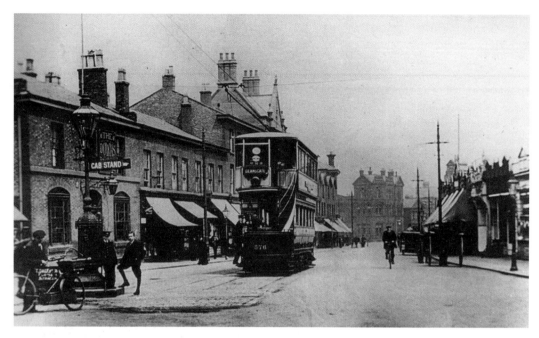

The junction of Railway Street and The Downs where the horse-drawn cabs met the trams at the terminus, photographed before 1914, when there were no route numbers posted up on the trams.

Passenger numbers on the Altrincham and Manchester Railway continued to grow despite the competition from the trams and bus services, latterly the motorcar. By the beginning of the 1930s there had been a massive increase in commuters: seven million people used the Manchester South Junction Railway service in 1931. This was the era of electrification for railways, which began in the 1920s. Competition from other forms of transport had not yet obliterated railways but the effects were just beginning to be felt. For instance, the electric powered trams could ferry people to the town centres, stopping outside shops and markets, while the railways could only drop passengers off at designated stations. Towards the end of the 1920s the Ministry of Transport investigated electric power systems for railways, and in 1928 the Ministry finalised the project by recommending the use of overhead cables, using a 1,500-volt DC system. Simultaneously, the committee of the Manchester South Junction and Altrincham Railway were also working on an electrification project, and when the Ministry recommendations were published, plans were made to adopt the 1500-volt overhead system. Construction began in 1929, and the first electric passenger train in the world travelled from Manchester to Altrincham on 14 April 1931. From 11 May 1931, passengers saw the last of the steam trains on the route, and electric trains were put into regular service. Journey times were cut, more trains were put on during the day, and new stations were opened at Navigation Road and Warwick Road. The last electric trains journeyed from Manchester Oxford Road and from Altrincham at five minutes past nine on Christmas Eve 1991. An article in *Railway World* in March 1992 lamented the lack of special celebrations as the electric trains disappeared – there could have been special excursions on the round trip from Manchester, festivities, fireworks, and champagne corks popping, but as it was, the train that arrived in Altrincham discharged its few passengers, and then went quickly back to the depot with only the driver and the guard on board. The end of sixty years of electric railways was allowed to pass by with only a modest celebration. The replacement for the electric railway was the new Metrolink tram service, which opened in 1992.

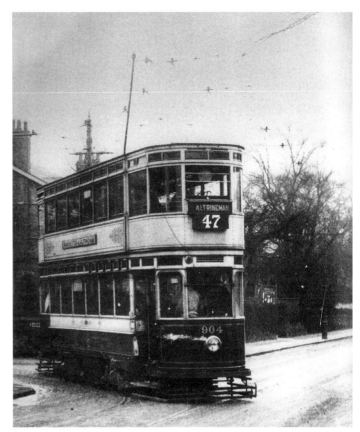

Right: Tram on route 47 on its way to Altrincham, photographed at Barrington Road.

Below: Open-topped tram on Stamford New Road near the railway station.

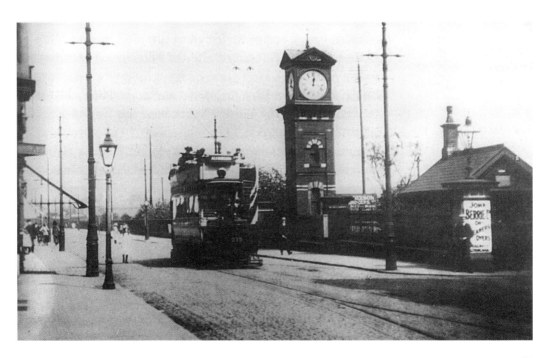

Tram on Stamford New Road with the station in the distance.

Motorised buses competed with the trams for two or three decades. This is a charabanc with individual doors like a stretch limousine, and luggage rack on top. It belonged to the Altrincham Bus Company, and is seen here on Oakfield Road in the 1920s.

Motorbus services were operated by several different companies from the 1920s. Altrincham District Motor Services Ltd was incorporated in 1922, but was soon bought out in 1925 by the North Western Road Car Co. Ltd which was based at Charles Street, Stockport. All twenty-six motor buses, lands and buildings belonging to Altrincham and District Motor Services were taken over by the Stockport based company, including 767 square yards on Stamford New Road 'together with the building and erections now standing', and the 1,274 square yards on Kingsway, 'together with the four cottages, workshops, stable, and outbuilding'. In a street directory for 1927, the North Western Road Car Co. Ltd is listed at 38a Stamford New Road.

Private motorcars began to appear during the first half of the twentieth century, presumably for the select few who could afford to buy a car and run it. In most parts of the country when motor cars were novel and rare, and the garage trade had not yet become firmly established, people used to take their cars to be mended at the blacksmith's, so that there was a doubling up of trades until the need dwindled for metal work for carts and wagons, and the shoeing of horses, and the need for motor maintenance and repairs increased. For instance, at the turn of the nineteenth and twentieth centuries, there were no firms dealing with motorcars in the Altrincham trade directories until the appearance in 1903 of one motorcar manufacturer, Ralph Jackson, on Oakfield Street, but no other garages or repairers were in evidence. The trade grew rapidly after this initial modest start. Only a decade later in 1913, several firms had been established. Three of these were listed under the heading of 'motor car garages': Cragg & Sons, Old Market Place; Edgar Harding, 1 Church Street; James Ward, Victoria Garage, Victoria Road, Hale. More ambitious were the motor car manufacturers: The Phoenix Motor Co., Oakfield Street, and J.Richardson and Co, Unity Garage, Dunham Road. Under motorcar repairers and also motorcar manufacturers there was Albert Bullock, 169 Manchester Road, with works depot at Salisbury Road, Broadheath. By 1927 Altrincham Garages had opened up on New Street; Elf Motor Engineering Co. had established itself on Viaduct Road, Broadheath, and Herbert Hill had set up at 36 Church Street. Ralph Jackson moved from Oakfield Street, and had combined with Edwards, to become Jackson (Ralph) & Edwards, Manchester Road, West Timperley. The directory also lists James Roscoe, 1a Moss View. The age of the motorcar had begun in earnest.

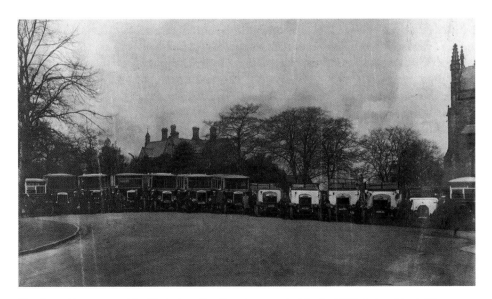

The fleet of buses owned by Altrincham Bus Co, photographed in the 1920s before North Western Road Car Company bought out the firm.

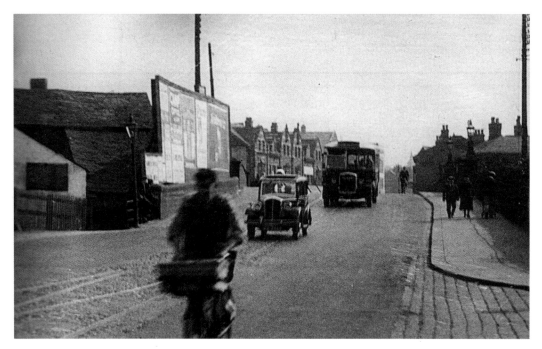

Altrincham Bridge with early single decker bus and motorcar. On the back of the photograph is written 'The bottleneck on the main Manchester to Chester road caused by the narrow bridge over the Bridgewater Canal at Broadheath will shortly be removed when a new bridge costing £75,000 is constructed'. If only the writer could see how the bottleneck looks now ...

Manchester Road at Altrincham Bridge in 1937 with the Manchester Corporation 47 bus going into Altrincham. The white building just visible in the centre of the photograph is the Regal Cinema.

The 47 bus coming out of Altrincham at Altrincham Bridge.

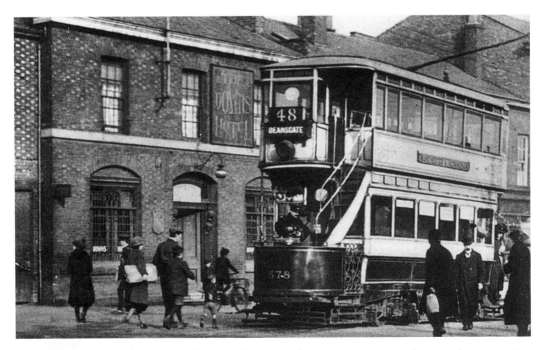

Changing times and changing fashions, but the more it changes the more it stays the same: the tram service was replaced by the motorbus, but the route numbers remained the same.

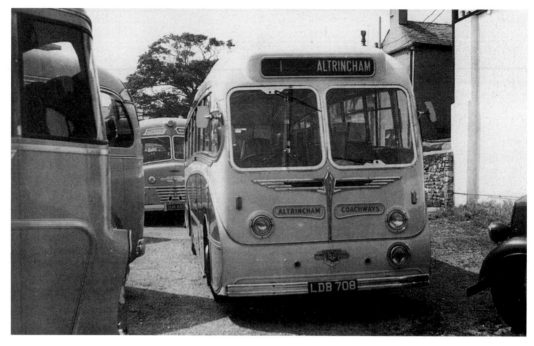

Superbly decorated 1960s coach belonging to Altrincham Coachways.

The bus station at Altrincham used to be on the opposite side of the road to the railway station, until Altrincham Interchange was built to accommodate buses and the Metro.

View of the bus station from Stamford New Road. The squat single-decker bus next to the double decker is probably one of the specially built low buses that were used on the Warrington route through Dunham Massey. Ordinary buses would not go through the 'underbridge' as it was known, that takes the road underneath the Bridgewater Canal just outside Dunham Park.

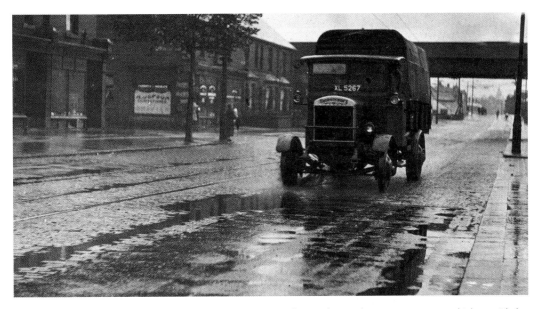

The road surfaces underneath the modern tarmac are often made up of square stone setts, which provided a durable surface, but were slippery and not very smooth for motorised transport. The stone setts and the tramlines can be clearly seen in this photograph of a covered lorry travelling along Manchester Road in the rain. The old Broadheath railway can be seen in the background. Nowadays only the ramp with the arches remain, behind Halfords.

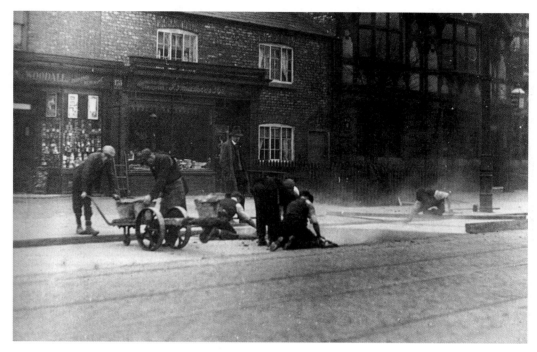

This is Manchester Road in Broadheath under repair.

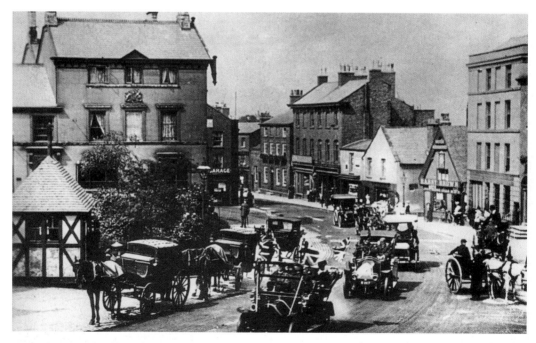

Private motorised transport was a feature of the late nineteenth and early twentieth centuries. This photograph shows a motor cavalcade, Union Jacks flying, through the Old Market Place, where the horse cabs still operated.

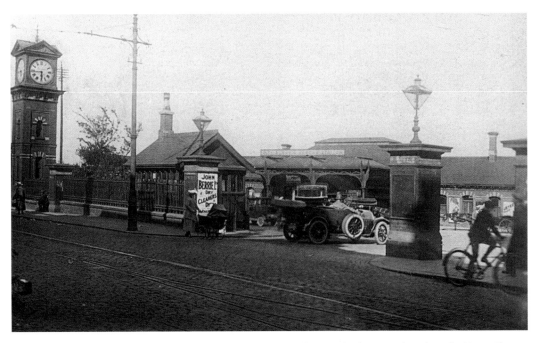

Open-topped tourer entering the railway station. This is when cars had running boards and white wall tyres, and were the prerogative of the wealthy.

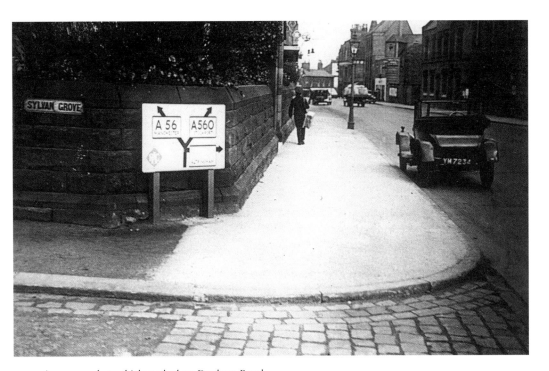

A more modest vehicle parked on Dunham Road.

Motor vehicles made deliveries of any commodities much easier and faster. These are Post Office vans appropriately parked outside the Post Office on Stamford New Road, in 1936.

Perhaps no one could have predicted how our car ownership would increase to the point where it was more difficult to move by car than on foot. This is George Street in the 1960s before pedestrianisation closed it off to traffic.

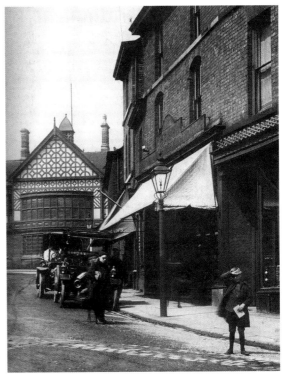

This page: Motor cars on Kingsway, with horse and cart. Motoring must have been a hazardous business when horse-drawn vehicles also ran on the same routes.

Chapter 4

Entertainment

Recreational pursuits were once more simplified. In the nineteenth century, what was on offer was perhaps just as diverse as it is now, but the outward forms have changed. Then as now, recreation had to be fitted in with working life, but in general people worked longer hours, and transport facilities were not as rapid, so there was a shorter range for outings and evening pursuits. In the modern world, there is talk of the leisure industry, a concept that perhaps would not have been understood in the days when darts and dominoes at the pub constituted a good night out (and still do, of course); but recreation has become more overt, more sleek and glossy, and more expensive. There are those who tell the tale that for half a crown (12 ½p) you could get a tram, go to the pictures, buy a Mars bar, and still have change. In the future, people might be telling their grandchildren that they will remember the times when you could go to the gym, have a shower, then have a meal in a restaurant, see a film, and still have change out of £100.

The choice of what to do with leisure time varies according to personal taste. From the later nineteenth century there were parks and open spaces for the public to enjoy in Altrincham, with gardens, bandstands and swimming pools. Stamford Park was opened in October 1880 on sixteen acres of land, a small part of the area known as Hale Moss, which was donated by the Earl of Stamford. The opening ceremony was conducted 'amid a scene of enthusiastic appreciation unequalled in the history of this time-honoured town' according to the report in a special edition of the *Altrincham and Bowdon Advertiser*. There was a procession through the town led by the Mayor, followed by the members of the Court Leet, then the Local Board, and the burgesses of Altrincham, then the tradesmen and the fire brigade. In the evening after the opening of the park, there was a banquet for 150 guests at the Unicorn Hotel. The landscape gardeners who designed and laid out the gardens of Stamford Nursery, Bowdon. There was a bathing pond within the grounds of Stamford Park, and an open-air swimming pool, named King George V Pool, to the north of the park. This was another donation of the Earl of Stamford in 1937. On the 1898 map the area occupied by the pool is labelled 'fish pond'. Another park in the Altrincham area is John Leigh Park. This twelve-acre park was donated to Altrincham Corporations by Sir John Leigh, the owner of Oldfield Hall, which was demolished in 1917 after standing empty for some years. When the hall was pulled down the grounds were converted to public use.

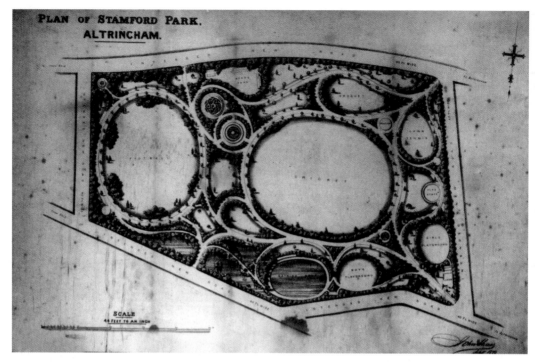

Plan of Stamford Park, drawn by the designer John Shaw. The park was opened in 1880, with a procession and banquet to mark the occasion.

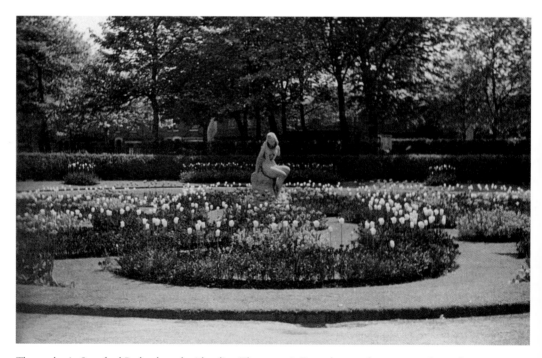

The garden in Stamford Park, planted with tulips. The statue is Eve, who gave her name to the garden.

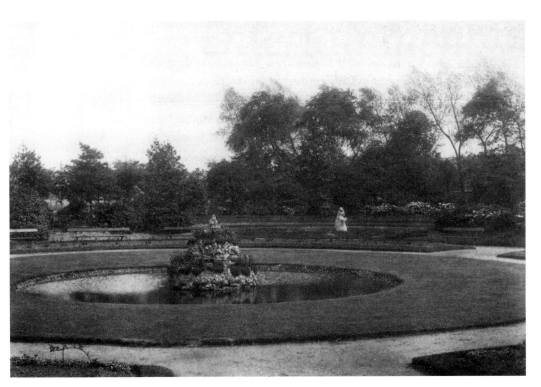

A wider view of the Eve Garden in Stamford Park.

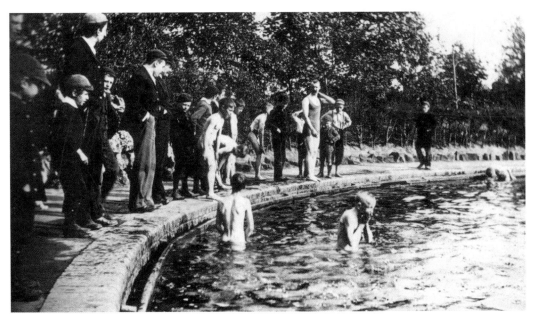

The public bathing pool in Stamford Park.

For the more energetic there were walks around the Altrincham area, taking in Dunham Hall and Park. A guidebook of 1864 gives instructions on how to reach Dunham Park by train from Manchester, at 10d for first class and 8d for second-class travel, alighting at Bowdon Station (the first railway station in Altrincham, at the junction of Railway Street and Lloyd Street). The guidebook continues: 'Leaving Bowdon Station, you ascend to the main road, and turn to your left. How clear is the town, how bright in the July sun! Proceeding past many pleasant houses and gardens, gay with roses, fuchsias and geraniums, the broad highway leads you to a road on your right which conducts to the Park'. The guidebook keeps up this jolly and optimistic commentary throughout its sixteen pages. Slightly more distant than Dunham was the Castle Mill Café advertising 'Lunches, Dainty Teas and Evening Coffees' for motorists, ramblers and small parties. The main attraction in the summer at Castle Mill was the swimming pool. For scenery and peace and quiet some walkers chose to visit Rostherne Church and Mere, or Warburton with its ancient church, or Lymm and its market cross. Guides books with titles like 'Country Rambles' suggested routes and times for the residents of and visitors to Altrincham, and when bikes became popular, special route maps for cyclists were published. Tourism was not a common pursuit for the average person until the 1950s and 1960s, but there were occasional Sunday School trips in the charabancs to Rhyl, Southport and Blackpool. For those who did not travel far, at home there was Altrincham Carnival, a long-established celebration that afforded an occasion for dressing up and parading through the streets. Money was collected in aid of the Hospital Fund, so the official title was Altrincham Hospital Carnival. The programme for 1924 outlines the route and procedure: the Chief Marshal was stationed at the junction of Market Street and Regent Road, with assistants near the Catholic Church on Bentwick Road and Groby Road. Competitors were to assemble between 1.30 and 2pm, with No.1 section in Market Street, No.2 section in Regent Road, No.3 in Bentwinck Road, and No.4 in Groby Road. At the head of the procession was the Chief Marshal (Mr J. Campbell in 1924), followed by the Old third Cheshire Military Band, then the carriages with the King and Queen of the Carnival. There was to be a gap of twenty-five yards between sections. The first one, for children, was preceded by a pipe band from Manchester, with dancing troupes, and costume characters, then the second section followed, with tableaux on lorries and the Altrincham and Broadheath Military Band, with the heavy horses of the traders' and farmers' carts and drays. Finally there were the decorated bicycles, cars and motorcycles, led by the Styal Cottage Homes Band. At 2.30 prompt the procession was to move off via Regent Road, through George Street, Stamford Street, Stamford New Road, Railway Street, The Downs, Delamere Road and Cavendish Road to the Devisdale, then the whole line would pass once before the Judging Ring before dispersing. Prizes were to be given at 6.30pm.

One of the features of the procession in the 1920s was the appearance of the Hazel Grove Silent Twins ('Ye Lads Who Never Smile'), who walked along collecting money from passers by, but never spoke. If anyone could make them smile or speak between the hours of 12.30 to 8.30pm, there was a prize of £1. For those spectators who did not throng the streets, but watched from upstairs windows, the collectors offered long tubes reaching to window height so that money could be passed down them to the receptacles below.

Sports enthusiasts were well catered for at the beginning of the twentieth century. Guidebooks to the town extol the bowling facilities provided by several clubs in Altrincham, Bowdon and Hale, then there were the cricket clubs, hockey clubs and football clubs in the area. Altrincham Football Club began life as the Rigby Memorial Club, from the boys who attended Miss Lee's Sunday School. The club used to play in Broadheath, firstly behind the Atlantic Works, and then in a field near Broadheath Station, before moving to another field at Davy House Farm. The club then moved to its grounds on Moss Lane. A brochure published by the club in the 1930s states that 'at first the club did not enjoy much success in the League and was always struggling at the

This photograph shows Oldfield Hall prior to demolition in 1917, when the grounds were donated to the town of Altrincham for use as a public park.

Entrance to John Leigh Park.

Small summerhouse in John Leigh Park.

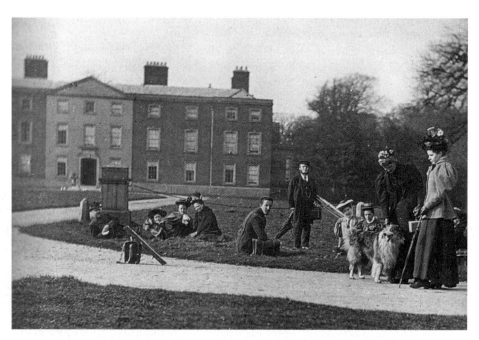

Dunham Massey Hall, the residence of the Earls of Stamford. For some time in the nineteenth century the Earls did not live in the house, and the Hall was occupied at the end of that century by contractors for the Manchester Ship Canal, which was opened in 1894. In 1905, the ninth Earl of Stamford decided to take up residence at Dunham and began to make alterations to the house. This photograph shows the staff enjoying a picnic on the lawns in front of the Hall as it looked before the alterations. The Park is open to the public, and is still a popular place for an outing for the people of Altrincham.

bottom' but improvements were made slowly but surely, and the Robins, as they are now known, are an important feature of the town, the ultimate accolade being their appearance at Wembley in the FA Trophy Final. The swimming baths in Altrincham are now situated in Oakfield Road, but there were facilities prior to this on Stamford New Road, opposite the station. These baths were built in 1896-7 to commemorate the sixtieth year of the reign of Queen Victoria, the costs being defrayed mostly by public subscription. In 1909 another larger indoor pool was added to the building. Another sports facility in Altrincham was the Ice Rink, home to many enthusiastic amateur and professional skaters, some of them reaching the headlines in the skating world. The new Ice Rink is opposite Tesco's, off Moss Lane.

Venues for non-sporting activities include the several pubs in Altrincham, and the current trendy bars and licensed cafes. Some of these have disappeared, for instance the Rose and Shamrock, on Chapel Street which has itself vanished; other pubs have either changed their names or are not entered in directories under any name at all. There were many beer retailers in Altrincham trading from what seems at first sight to be a private address, and indeed some people sold beer from their front rooms. The early history of several pubs began in this fashion. In the past, regulations for the maintenance of public order and for the trading standards in ale houses were somewhat severe. The rules stated that all drunkards were to be brought before the jury every time they were found in an inebriated state, and to pay five shillings, which was used for relief of the poor. If they had no money, the drunkards were placed in the stocks for six hours. Men who spent most of their time in taverns, sleeping by day and watching by night, as the rule put it, were also liable to punishment.

Dunham Massey Hall after the alterations, with a much more elaborate entrance and a lower roofline.

Altrincham Carnival was a special annual event, attended by many residents and non-residents of the town. This photo shows one of the groups in the procession, probably in the late 1920s. The drummer boy carries a sign on his drum saying 'Wooden soldiers'. As the group of six marches through Altrincham.

Afternoon and evening entertainment was provided by the cinema. There was once a time, in the 1930s, when Altrincham and Hale boasted five cinemas, four of which still kept going when television arrived and withdrew audiences from the big screens. Moving pictures were the great invention of the late nineteenth and early twentieth centuries, and many enterprising people established cinemas all around the country. The early cinemas were often converted theatres, and some of them put on live shows as well as showing films, such as the Hippodrome on Stamford Street, which advertised light entertainment shows.

The first permanent cinema was the Central Theatre, on Shaw's Road. The building had been used for several different purposes until it became the Shakespeare Theatre in 1906 and was converted to a cinema in 1907. In 1910 the film of the Royal funeral of Edward VII was shown, and proved popular enough to be retained one week longer, including scenes of the Royal Chapel at Windsor. The advertisements proclaimed that the film was accompanied by Chopin's *Grand Funeral March* played on the organ by Mr Frank Noble, whose firm F.R. Noble & Sons, of 19 Railway Street and also 47 George Street, provided the organ.

Altrincham Picture Theatre was built in 1913. The *Altrincham Guardian* for 10 October of that year reported that rapid progress had been made with the erection of the new picture theatre. This was the first cinema that was purpose-built and not converted from an existing theatre. The newspaper went on to say that it was hoped that the cinema would be ready by Christmas 1913, and when finished it would be a handsome addition to the architecture of the district. It was convenient for the railway service, since it lay almost opposite the station, and also lay on the tram route to and from Manchester. The cinema was quite large with seating for about 1,100 persons, and the entry tickets were priced according to seating position. The newspaper reported that there was to be efficient ventilation for comfort

Six wooden soldiers and their drummer boy at Altrincham Carnival.

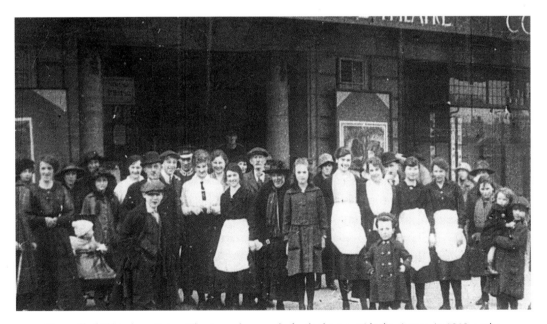

The staff of Altrincham Picture Theatre and a crowd of onlookers outside the cinema, in 1919, as the procession went by, on its way to unveil the Chapel Street Roll of Honour, commemorating the men from this little street who served and died in World War One. This image is from a film that was made of the event.

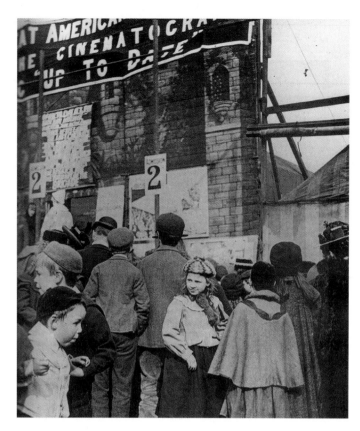

When films were still young: The Great American Bioscope come to Altrincham. In *Cinemas of Trafford* D. Rendell suggests that this event may have been put on when the travelling fair came to Hale Moss in c.1900. Films were very short, lasting for about a minute, but since moving pictures had never been seen before the impact must have been tremendous.

of customers, and the inside was decorated with artistic finishings. The architect was T.A. Fitton, and the building work was carried out by Messrs Hollinworth & Co of Patricroft. The manager of the cinema from 1927 until sometime after 1939 was Leonard Pearson. The Picture Theatre survived until 1966, and the author remembers dashing out of school, at an impressionable age, to catch the matinee performances (plural) nearly every day when *Ben Hur* was shown in glorious colour and Cinemascope. The site is now occupied by the Station House office block.

Another purpose-built cinema was erected in Hale, though not without protests from the residents. The idea had been floated before the outbreak of World War One, but opposition continued to delay the work. It was not until 1923 that Cinema House (Hale Pictures Ltd) opened on Willow Tree Road, Hale. It was more commonly known as Hale Cinema. In 1927 there was a veritable orgy of Rudolph Valentino films. The adverts proclaimed: 'Your last chance to see the Great Actor in Six Different Films'. On Monday: *Sainted Devil*, Tuesday: *Cobra*, Wednesday: *Sainted Devil*, Thursday: *Monsieur Beaucaire*, Friday: *Blood and Sand*, Saturday: *Son of the Sheik*. The programme was supported by Charlie Chaplin films, on Monday to Wednesday *The Pilgrim* was shown, and Thursday to Saturday the film was *Carmen*.

The Hippodrome on Stamford Street opened in 1912. It was originally built as a theatre by Thomas Hargreaves, whose company was still in ownership of the cinema in 1939, listed as Thomas Hargreaves Ltd, (proprietors). Live performances and concerts were given, as well as films.

ALTRINCHAM PICTURE THEATRE,
STAMFORD NEW ROAD.

Exhibition of **First Class Pictures**
With Orchestral Accompaniment.

Popular Prices: **4d. 7d. 9d. & 1/-** (Balcony).
Tax: 1d. 2d. 3d. 3d.

OUR PICTURES **are shown on a** PRISMATIC SCREEN,
giving an unequalled STEREOSCOPIC EFFECT.

38

Right: Advert for Altrincham Picture Theatre in the silent era when live music was played for dramatic effect. Many picture houses had to make do with a solitary piano rather than the orchestra advertised here.

Below: Aerial view of the Regal Cinema, on the site now occupied by Roberts House. The cinema was opened in 1931 and burned down in January 1956.

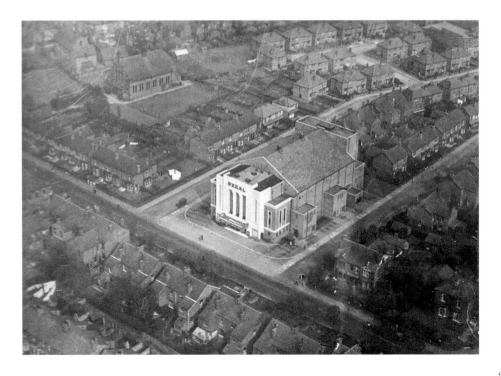

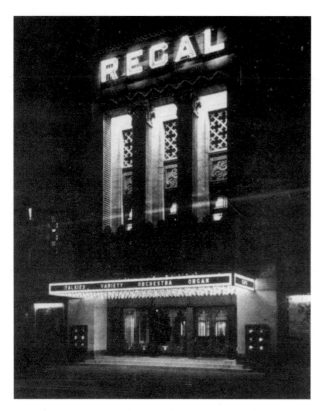

Left: The Regal frontage at night, ready for the evening performance.

Below: Interior of the Regal Cinema, taken from the circle.

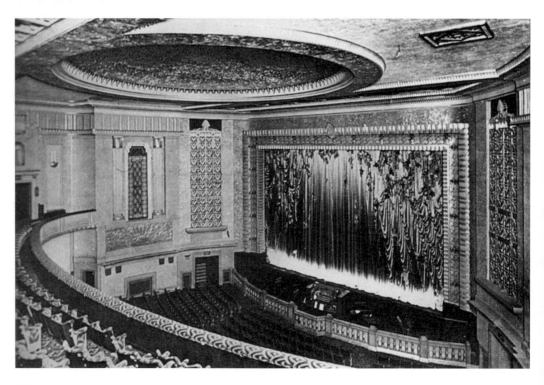

When life became difficult for cinemas in general in the 1960s, the building was converted to a Bingo Hall on the ground floor and a smaller cinema on the upper floor. The Hippodrome survived until 1986, and was demolished in 1987.

The Regal (Associated British Cinemas Ltd) was situated at 80 Manchester Road. Opened by the Earl of Stamford in 1931, the cinema was purpose-built, and was a striking building. An article in *The Bioscope* of 20 May 1931 describes the main features of the cinema. The architect was Joseph Gonersall, of Drury and Gomersall, Oxford Road, Manchester. The façade was described as 'vigorously modern', with the only jarring note the brickwork on either side of the decorated stonework. The interior was sumptuously decorated, living up to the catch-phrase picture palace, with dancing nymphs of the Egyptian period, as the article described the sculptured scenes. There was seating for 1,800 people, 550 in the balcony, and 1,250 in the stalls, and a Crompton organ console on an electric lift. The orchestra pit was illuminated with multi coloured lights. Those who have seen only the modern, rather Spartan new cinemas cannot imagine what an experience it was to go to the Regal to see films.

The theatre tradition has always been very strong in Altrincham. The Club Theatre can trace its origins back to the 1880s, though it was not always known by the same name. The Club Theatre was formed in 1947 after the war, with its premises at St Margaret's Institute, Market Street. In 1960 the organisers were notified that the owners of St Margaret's Institute wanted to sell the building, and, after negotiations, the theatre company moved to the Methodist Chapel on Oxford Road, where the members of the society spent a frenetic time in converting the chapel into a theatre. The Club Theatre opened on 27 November 1962, with a performance of *Don't Listen Ladies*, by Sacha Guitry. In April 1972 the society celebrated their tenth anniversary at the Excelsior Hotel, Manchester Airport.

Altrincham Garrick Theatre started life in 1913, when W.S. Nixon of Stockport Garrick Society floated the idea of forming a similar group on Altrincham. The first few members used the basement of a shop on Kingsway as their headquarters, where the Altrincham Garrick society was founded at the beginning of 1914, which means that within less than three months the founding members of the society had found a play, rehearsed it, negotiated for premises, obtained or made costumes, borrowed the scenery from the Gaiety Theatre Manchester, and put on the performance. Anyone who has the slightest knowledge of such labours will realise what work this must have involved.

After receiving advice from no less a person than George Bernard Shaw, the Garrick became a Repertory Company with paid actors, and a building fund, which was started in 1920. Money-raising activities were set in motion, and in 1926 a plot of land was purchased on Barrington Road, by a Society member who remained anonymous. Building began in 1931, and the theatre opened in October 1932, with the production of *The Immortal Lady* by Clifford Bax. Since then the Garrick has gone from strength to strength, weathering all storms and putting on plays and concerts with famous names in starring roles. The theatre was remodelled at the end of the 1990s, after several years of fund-raising to provide for the cost of restructuring. Long may it reign.

Altrincham was the birthplace of the playwright Ronald Gow, born 1 November 1897, and educated at Altrincham Grammar School for boys, then at Manchester University. He pursued a career as chemist, then as a teacher, but he was always interested in amateur dramatics from an early age. He was associated with the Garrick Theatre, Manchester. He was famous for his adaptations of novels, one of which was *Love on the Dole* by Walter Greenwood, written in the 1930s. He met the actress Wendy Hiller who was born at Bramhall, Cheshire, in 1912), who played the lead on stage in this play in England, and then in New York in 1936. Gow married Hiller, who became a film star and eventually Dame Wendy Hiller in 1975. He adapted more novels for stage, including *The Edwardians* by Vita Sackville-West and *Watch and Ward* by Henry James, which was retitled *A Boston Story*. He also wrote plays of his own, the last one being *The Old Jest*, starring Wendy Hiller in the leading role, staged in the West End of London in 1980. Ronald Gow died in April 1993.

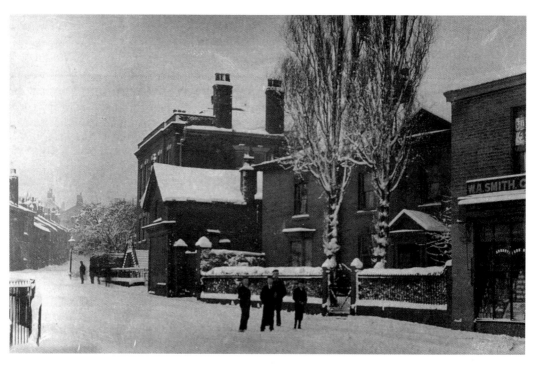

Stamford Street before the Hippodrome was built.

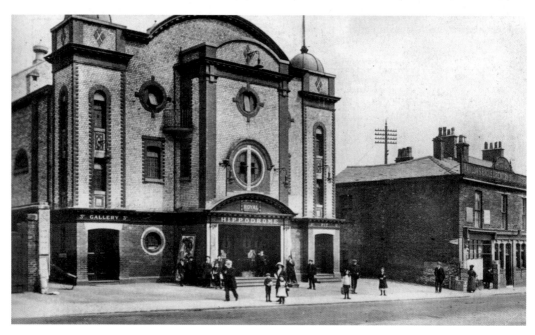

The Hippodrome, c.1914, when the building was about two years old. It was originally built as a theatre, and the management continued to put on live shows as well as films.

One of the regular annual events that attracted crowds of residents and non-residents was the Altrincham Agricultural Society Show that was held for many years on the Devisdale, between Green Walk and Groby Road. The Agricultural Society was founded in 1861, and was a member of the Federation of Lancashire and Cheshire Agricultural Societies. The presidents of the society were distinguished men from the old nobility, with the name Egerton or Tatton frequently appearing in the annual lists. The Earls of Stamford also featured in the society; in 1922 the Earl was the president and in 1950 the Countess of Stamford acted as patroness. The rules of the show were drawn up to deal with membership and the running of the society and for the regulation of the show itself, which was usually held in September. There was a deadline for entry qualification, and the Show Yard was to be open at 7am to admit stock. The animal categories included cattle, horses, pigs, dogs, poultry, rabbits, cavies and pigeons. Non-animal categories included implements, grain, horticulture, honey, butter, and cheese. By 1957 the society was in financial trouble, sustaining a loss of £2,000 in that year. The show was the largest in the North in its heyday, and is sadly missed.

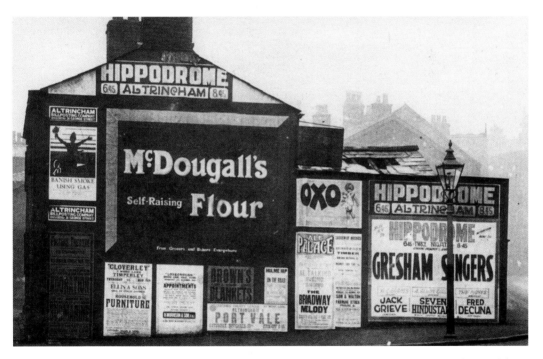

Advertisements for cinema and theatre performances. At the Picture Theatre, the billboard at bottom left and in shadow, announces the showing of *Adoration* and *Submarine*. Both films were released in 1929. The Hippodrome was hosting a concert performance, announcing the Gresham Singers, twice nightly at 6.45 and 8.45.

Unicorn Hotel
ALTRINCHAM.

FIRST-CLASS COMMERCIAL.

Officially appointed Hotel of the Automobile Association.

Ordinary Daily at 1 p.m.

Every accommodation for Large Parties

Billiards. Bowling Green.

Garage (I.P.). Stabling.

Tel. 1436.

CHAS. F. REDFORD, Proprietor.

54

Above: The Unicorn Hotel in the Old Market Place has undergone several changes of name in its life. When the Town Hall and the market were located in this vicinity, there would have been brisk business in the hotel. Sited on the coaching route to Manchester and Chester, the hotel prided itself on its accommodating livery stables. It is now appropriately called the Old Market Tavern. This photograph was taken when it was still called the Unicorn, and the old Town Hall can be seen at the back of the building, on the extreme right of the photo.

Left: In the age of the motor car, the Unicorn was an officially appointed Automobile Association hotel, but note that the advert still mentions stabling as well as the garage for cars.

Motor cars parked in the Old Market Place outside the Unicorn Hotel.

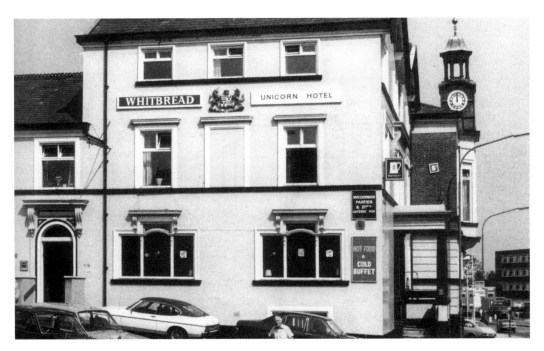

The Unicorn and the old Town Hall photographed in the early 1970s. The sign between the second floor windows has been painted over, but the crest above it is resplendent with new paint. Tourism was an established form of entertainment by the 1970s, creating a need for new hotels; the Cresta Court hotel can be seen on the right of the photo.

The Unicorn in new guise, with window blinds and a new name. The Whitbread sign has been inserted where there was once a billboard advertising the services offered by the management.

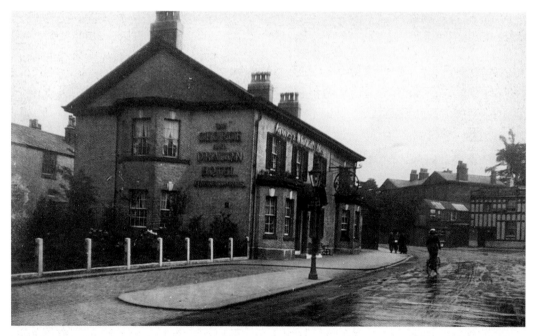

The George and Dragon and the Wheatsheaf on Manchester Road. In 1905 the George and Dragon was run by William Parks, and by 1901 Mary Ann Arnold had taken over. Walter Frost ran the Wheatsheaf in 1905, succeeded by James Watson Trotter by 1910.

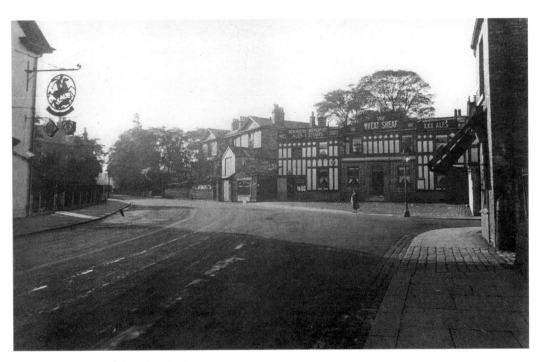

A closer view of the Wheatsheaf.

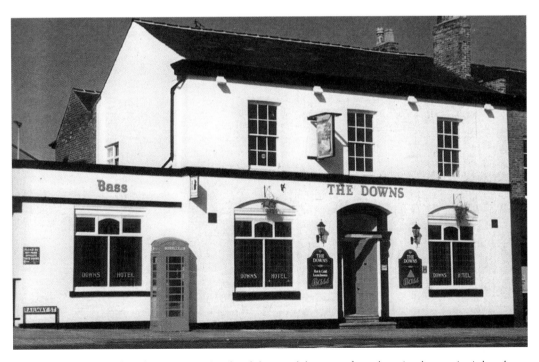

The Downs Hotel, Railway Street, painted and decorated, but apart from the paint the exterior is largely unaltered, with elaborate ground floor windows. George Redgate Ashcroft managed the pub in the early years of the twentieth century.

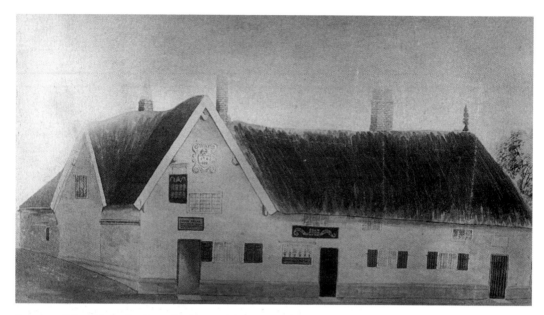

Drawing of the Old Woolpack on the corner of Regent Road and Railway Street. This is the original building, with the date 1699 on the shield above the door. This date may refer to alterations made in that year; the pub may have been established much earlier. The Woolpack was rebuilt in 1865 on the same site, and retaining the same name. Its address in street directories is 12 Railway Street, and the landlord was John Armstrong from about 1905 until after 1910.

The Rose and Shamrock, Chapel Street. This pub is not named in street directories until the 1930s, but the premises were used to sell beer. In 1909, Mrs Julian Manion is listed as a beer retailer at No.18 Chapel Street; by 1927 Daniel McDermott had taken over, and in 1939, Dominic Nolan is listed at the Rose and Shamrock at the same address. The pub was demolished in 1958.

The Royal Oak on Stamford Street. The address of this pub in street directories is 14 Stamford Street where Frank Mills is listed as a beer retailer in 1927, but the pub name is not mentioned until the 1930s. Three other beer retailers are listed on Stamford Street besides Frank Mills, all on the opposite side of the road at No.19, John Arthur Warren; at 29 Michael Nolan, and at 39 Ralph Ashton.

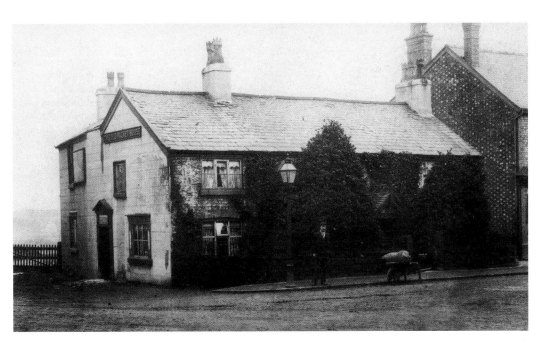

The Old Packet House in 1905. This was one of the stopping places for those travelling on the Bridgewater Canal.

1970s view of the Old Packet House.

This arch was erected on Station Road (Kingsway) to mark the occasion of the royal visit of the Prince and Princess of Wales in 1887. There was a similar arch on Dunham Road.

Garland dance by schoolchildren, to celebrate the coronation of George V, 22 June 1911.

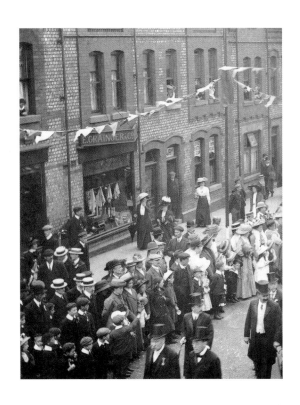

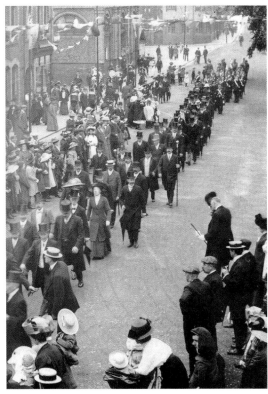

This page: Procession on Market Street, 22
June 1911, to celebrate the coronation of
George V.

Chapter 5

Industry

Two hundred years ago Altrincham had a stake in the textile world, with at least three textile mills established in the town at the turn of the eighteenth and nineteenth centuries, and over a hundred handloom weavers working in the area. In a pamphlet written in 1897, it is stated that the staple industry of the town at the turn of the eighteenth and nineteenth centuries was handloom weaving, and 'all the houses in Chapel Street were fitted up with looms'. The textile mills were at the eastern end of the town, around the appropriately named Mill Street, until the 1830s when they were closed. For a short time in the 1870s and 1880s there was a velvet works, or fustian cutting shop in Altrincham, situated on Hamon Road, which led off from Manor Road, the premises being labelled Halemoss Works on early maps. The factory was established in 1872, but the business ceased in the mid 1880s and the premises were eventually converted to use as a carriage and motor body works run by Litherland Brothers. The development of industry in Altrincham depended very much upon transport, and the economic situation of other towns within the vicinity. The Manchester cotton industry was responsible for the growth of Altrincham as a residential town, when the business owners began to build large villas on the outskirts. Altrincham's history was from then on intertwined with that of Manchester, almost as a suburb, rendering services to the city and relieving stimulus from it. As transport improved so did business and industry. The Bridgewater Canal facilitated the carriage of goods and raw materials in the eighteenth century, but the establishment of factories in the Broadheath area did not begin in earnest until the later nineteenth century, when railways were established. The Manchester South Junction and Altrincham Railway arrived in 1849, and the Timperley and Altrincham Junction Railway was opened in 1866. This railway was connected with the Manchester South Junction and Altrincham Railway at Timperley junction in 1878, and was opened for traffic on 1 December 1879. Broadheath Station was one of the stops on the Warrington and Stockport line. Thus the area round about Broadheath was gradually ringed with railway lines, as shown on the maps of the early twentieth century. The railways enabled heavy goods to be transported on a larger scale than the canals. Later on the tram service developed, providing transport for workers to and from the rapidly growing industrial site at Broadheath.

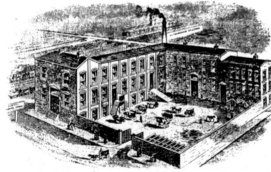

LITHERLAND BROTHERS,

Coach Builders, &c.

RUBBER TYRES A SPECIALITY.

LITHERLANDS' CENTRAL CARRIAGE WORKS, ALTRINCHAM.

**Motor Cars Trimmed and Painted
by Experienced Workmen.**

Cape Hoods, Aprons, and Dashes fitted.

▼▼▼▼▼▼▼▼▼▼▼▼

CENTRAL CARRIAGE WORKS,
Manor Road, Altrincham.

Above: Broadheath was a rural area with farms and fields before industry moved in at the end of the nineteenth century. This drawing depicts Woodall's Farm, which was removed to create Beaconsfield Road. On the Ordnance Survey maps of 1874 and 1898 the farm is shown as Massey Farm, and street directories show that was inhabited by Isaac Woodall until 1901. By 1902 the houses on Beaconsfield Road had been built, and Woodall had moved to a terraced house on Manchester Road, facing the Cheshire Cheese pub. Presumably he retired from farming, since he is listed not as a farmer, but as a householder.

Left: Litherland Brothers Central Carriage Works superseded the old Velvet Works on Hamon Road, off Manor Road in Altrincham. From 1898 until 1916 the firm is listed as Litherland Brothers, and from 1916 until 1927 as Litherland Brothers and David Litherland, coach builders. By 1939 the business was described as motor body builders, reflecting the change from horse-drawn vehicles to motorised transport.

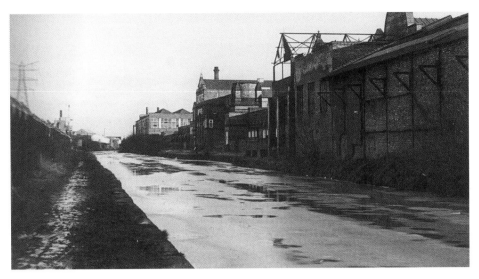

This photograph shows the Bridgewater Canal c.1984, in an era when industry was declining. The canal was once lined with factories all actively producing goods and providing employment for many of the people living around the Altrincham area.

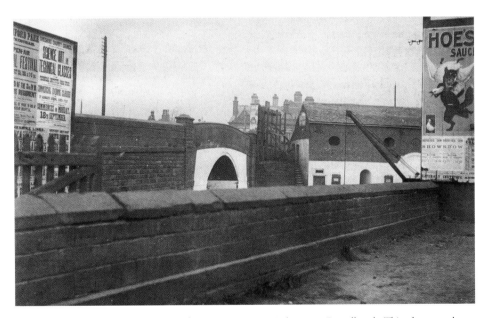

Ease of transportation was the major factor in attracting industry to Broadheath. This photograph of the old Altrincham Bridge shows one of the cranes on the wharfside. The Bridgewater Canal was begun in 1759, and the first sections from the Duke of Bridgewater's mines at Worsley were in operation by the second half of 1761. The sections that ran through Broadheath, Dunham and Lymm were built a few years later, opening to traffic to and from Broadheath by 1775. The first canal boats and barges were towed by horses walking on the towpaths, but the horses were later made redundant by the growing use of steam-powered boats. The goods carried on the barges were predominantly coal and timber, and stone, as well as raw materials and finished goods to and from the factories that sprang up on the banks of the canal. The boats could carry goods and passengers to and from Manchester, and also farm produce was carried to the Manchester markets.

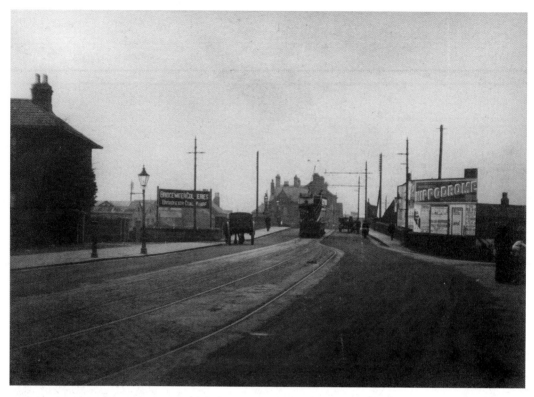

Looking towards Atlantic Street on Manchester Road, Broadheath, where Altrincham Bridge crosses the Bridgewater Canal. There are several forms of transport visible on the bridge, tram, horse-drawn cart, bicycle, and motorcar. On the left of the photograph the signboard advertises the Bridgewater Collieries, which had offices in Broadheath and Sale.

There was a marked predominance of machine tool and engineering works in Broadheath. The location of the canal influenced the siting of industrial premises, and for over a mile, where the canal passes through Timperley and Broadheath, both banks were lined with factories. The land near to the canal was not suitable for agriculture, so the establishment of an industrial area did not uproot too many farms or deprive the town of agricultural produce, but on the other hand it did provide employment for the people of a wide catchment area all around Altrincham, the only serious rival being Trafford Park. At the end of the nineteenth century, when the heavy industrial plants had just started to develop, the author of an article on the development of Altrincham deemed it 'improbable that great industries should deposit themselves in the despised hamlet of Broadheath'. These strong words were slightly modified by the sentiment that it was useless to complain, because 'the world refuses to stand still', and the changes would perhaps result in 'an increase of activity, a keener intellectual life, and a higher view of the duties and responsibilities of citizenship'.

The first firm to arrive in the area was G. Richards and Co. Ltd, which was established in 1885. The company proved so successful that in 1913 the firm expanded, acquiring a site near to the original works, but on the opposite side of the railway line. On this new site the firm built a new works, designed to supplement the original factory. The new factory was fitted with electrically driven machinery, including ten-ton cranes in each 40ft bay within the main machine shop. The

power was supplied by the Altrincham Electric Supply Ltd. In the article about the company in the *American Machinist* for 25 January 1913 it was reported that a new foundry was to be erected at the side of the works, and there was to be a separate office block. As an illustration of how much public services have improved since 1913, the glowing account of the works was rounded off with a description of the concrete reservoir built at the end of the main factory shop, for the storage of rainwater, because at that time 'while a good supply of water can be obtained for domestic use, the public supply does not extend to water for manufacturing purposes'. In the late 1920s George Richards and Co. Ltd issued their catalogues for 'surfacing, boring, milling, drilling and tapping machines' describing the location of their premises on both sides of the London Midland and Scottish Railway line, between Manchester Corporation electric trams nos 47 and 48. In 1902 Richards was merged with Tilghman's but continued to trade under its own name. Tilghman's was a firm that manufactured sand blasting machinery, starting out in London and then in Sheffield. The company moved to Broadheath in 1896, and at the same time took over George Richards & Co., with which it merged in 1902. Tilghman's were the first in the field for specialised shot blast equipment for etching glass and for sharpening files. In the twentieth century the firm was called Tilghmans' Wheelabrator Ltd, continuing to produce shot blast equipment for the control of air pollution.

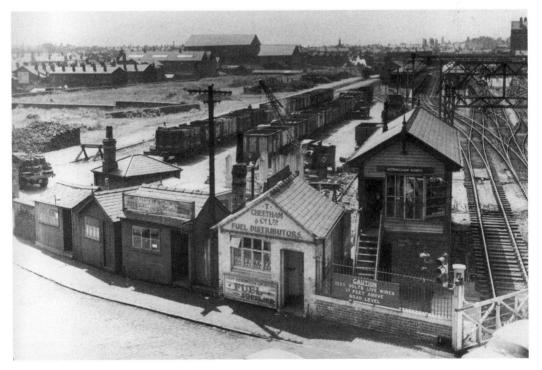

Industry was fed on coal. In 1898 there were over a dozen coal merchants and coal owners in Altrincham, concentrated around the station area, the most popular address for their offices being Stockport Road and Stamford New Road. This photograph shows the on site offices of James Fletcher and Thomas Cheetham in the late 1950s. Both these firms were established in the town at the end of the nineteenth century.

A later view of Altrincham Bridge. The Bridgewater Colleries sign has been replaced by the Manchester Collieries. The side of the building on the right of the photograph has been entirely given over to advertisement, except for one small window, left uncovered.

Another of the early occupants of the Broadheath industrial estate was a photographic firm, called Thornton and George and Edgar Pickard in 1888. John Thornton had already opened a business in Manchester producing cameras, and he was joined by Edgar Pickard who came from a family of grocers in Mansfield, Nottinghamshire, but was very interested in photography. The two formed a partnership, and moved to new premises at Broadheath in 1891. After his resignation John Thornton set up a film factory, The Thornton Film Company Ltd on Oakfield Street. The Thornton-Pickard works was eventually occupied by Tilghman's offices and canteen.

As Frank Bamford was able to show in his book on Broadheath, there were at least 14 companies established in the area by 1914. Charles Madan was set up in 1903, manufacturing pumping equipment, and H.W. Kearns, producing machine tools, arrived in 1907. In a manuscript memoir by P.G. Thomason in the collection at Trafford Local Studies Centre, it is stated that before the Kearns factory was built in Broadheath, the firm started out in a rented room in the offices and generating works of the Altrincham Electric Supply Company on Davenport Road. The founder of the firm, H.W. Kearns was a friend of the managing director of Richards and Tilghman's, which had merged in 1902, so Kearns would be familiar with Broadheath and the potential it offered for a new factory in a pleasant area with a ready supply of skilled labour. The Kearns family lived at Gisburn, which is now in Lancashire but was then in North Yorkshire, and the managing director Mr Joe Kearns took lodgings in the week in Broadheath. The Kearns later moved to a large house called Boothroyd in Brooklands. The Budenberg Gauge Co. Ltd was founded as a branch of Schaffer and Budenberg of Magdeburg,

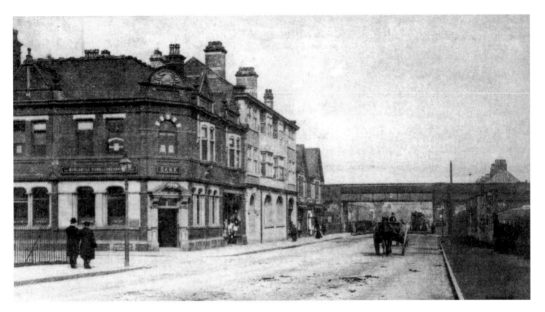

Manchester Road, Broadheath, showing the railway bridge and the corner of Atlantic Street. The station was behind the Thornton-Pickard works.

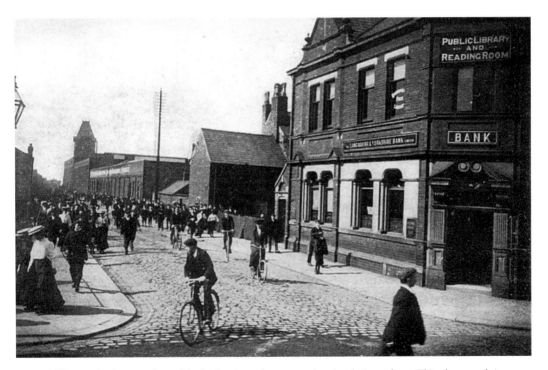

A Thornton's photograph used in the firm's catalogues to advertise their products. This photograph is entitled 'Dinner hour, Atlantic Street, Broadheath'.

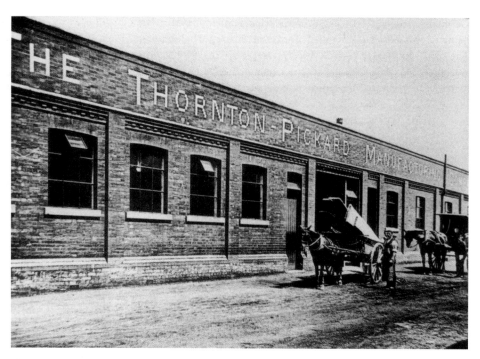

The Thornton-Pickard works on Atlantic Street, c.1896.

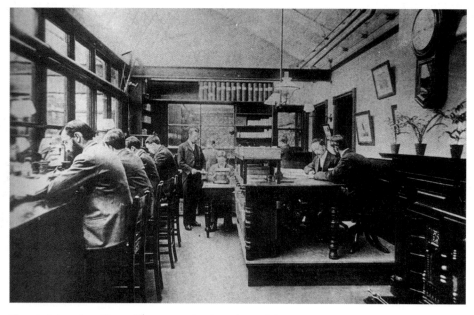

The administrative office at Thornton-Pickard works, with home comforts such as the fireplace and potted plants on the mantelpiece.

Germany. Originally based in Manchester, the firm moved to Broadheath in 1914, and changed its name in 1918. The Record Company was set up by John Record in 1911 on Atlantic Street. The firm produced measuring instruments.

Churchill Machine Tool Co. Ltd celebrated its Golden Jubilee in 1956. This company was founded by an American Businessman, Charles Churchill, born 8 July 1837 in Connecticut. His first visit to England in the 1860s to help set up some machinery from his father's engineering firm, and his observations while in this country convinced him that there was a shortage of machine tools that could be satisfied by importing them from America. He set up his first premises in Salford in 1901, and then moved to Pendleton in 1904. The Churchill Machine Tool Co. Ltd was formally set up as a new company in 1906. From 1910 onwards there was an increased demand for precision grinding, so it was decided to concentrate on production of this type of machine tool. As business expanded, new premises were sought, and in 1918 the firm bought some land from the Earl of Stamford in Broadheath. The site measured eleven acres. In 1919 the new factory was built, but unfortunately as World War One came to an end, there was a slump in the market for grinding machines. Churchill's survived because the firm manufactured a wide variety of machines, and found a profitable market in India, where the railway engineers were establishing maintenance depots to regrind locomotive parts. After another general slackening of business in the 1920s, Churchill's began to investigate electrically driven machines in the 1930s. In the 1950s the use of electric motors to drive individual sections of the machines had become widespread, and led to the establishment by Churchill's of rigorous standards for precision work, which were adopted nationwide.

One of the earliest companies to set up in the Broadheath area, and one of the most important, was the Linotype. This was a world-famous company with agencies in Britain and Ireland,

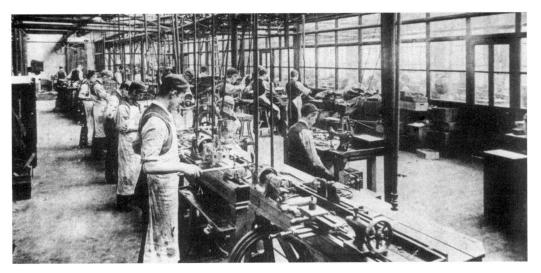

The metal workshops at Thornton-Pickard. Since cameras were built using several different materials, production was divided into the woodworking sections, metalworking sections, cabinet making for the camera bodies, shutter fitting, and brass finishing.

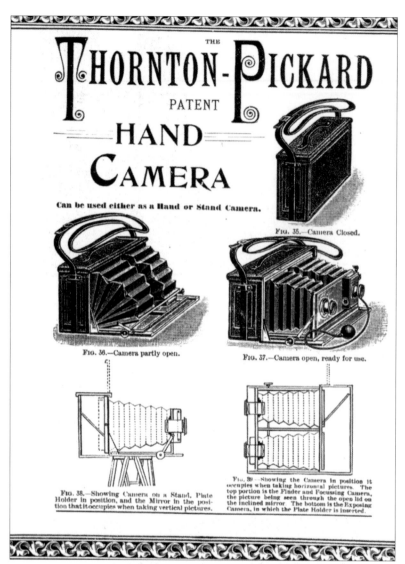

A page from
Thornton-Pickard
catalogue of 1895.

Europe and the Far East. The name of the company indicates its business, making lines of type from reusable matrices, a system that revolutionised the printing industry. Before the invention of Linotype, the printing business demanded skilled workers who set up type, piece by piece, from vast arrays of letters and symbols, which they had to set up the wrong way round in order that the printed page would read correctly. The job demanded people who could read upside down and in mirror image, and not make mistakes in selecting the punctuation marks, capital letters and special characters. To describe the new procedure extremely simply, the Linotype was run by an operator who typed the words and spaces on a special typewriter, and the machines selected the matrices, which were then assembled and coated in metal to create a solid 'line o' type'. Once the print run was over the metal could be used again.

The Linotype factory at Broadheath was built in 1896, and production started in the following year. There was an inauguration ceremony on 14 July 1899, reported in the Altrincham and

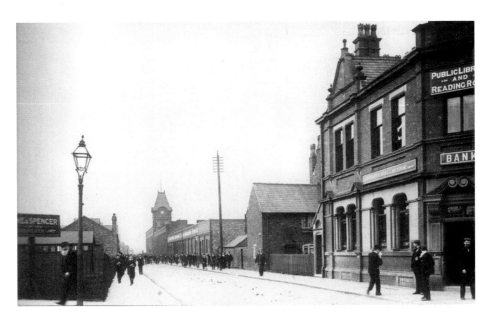

The junction of Atlantic Street and Manchester Road, with Luke and Spencer's works in the left foreground, and an oblique view of the Thornton-Pickard works on the right-hand side of the road. Workers are shown streaming out of the factories towards Manchester Road and the tram and railway services. The bank on the corner is not shown on the 1898 map, but the next edition of the same map shows that it was built by 1910. The Public Library was a branch of the Altrincham Free Library. The house that can just be glimpsed on the right-hand side of the road between the Bank and the Thornton-Pickard works is one of the group of Duke's Cottages, which survived until 1916, when eight people are listed there in the street directories.

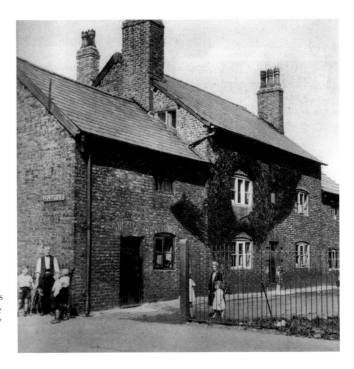

This photograph of Duke's Cottages clearly shows the road name 'Atlantic Street' on the side of the nearest cottage.

Above: Exterior of Kearns factory, c.1950. This firm was established in Broadheath in 1907, by H.W. Kearns, who produced machine tools. Before the factory was built, Kearns rented an office within those of the Altrincham Electric Supply Company, whose works bordered the Bridgewater Canal.

Left: Interior of Kearns factory.

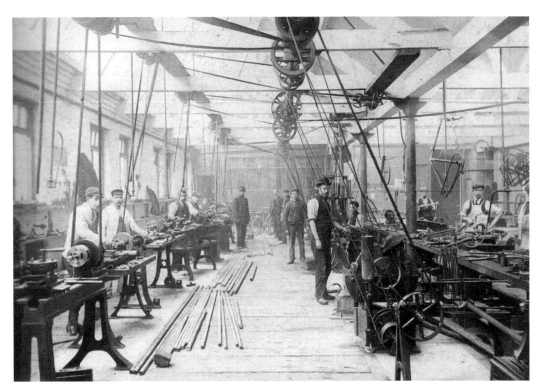

The workshop of Eagle Works, which was the factory of the Castleton Steam Packing Company on Atlantic Street.

Bowdon Guardian on 19 July, with a list of all the illustrious guests. A souvenir brochure was issued to mark the event. The Linotype works were housed in a huge single-storey building 650ft long by 260ft wide, with two-storey offices at the eastern end. The light and ventilation of the factory floor were considered exemplary, and supervision of the whole works was facilitated by the windows in the upper floor of the offices.

The situation of the works took advantage of the transport facilities offered by the road system and the Bridgewater Canal, and a company handbook boasts that coal and iron could be obtained at their cheapest in the region, which contained a higher proportion of skilled mechanics than any other area in the kingdom. Most of the major newspapers were composed by Linotype machines, two of the largest newspaper offices being the *Manchester Evening News* and the *Daily Telegraph* in London. In its heyday the Linotype factory at Broadheath employed up to 1,300 people, and in those times when the printing trade was flourishing there were up to 2,300 employees.

The Linotype Company was concerned for the well being of its workers, and built an estate near to the factory, comprising over 170 houses. The whole estate was laid out with the least possible disturbance to the trees around the site, and playgrounds and open spaces were incorporated into the plan. The houses still stand, and the factory buildings remain, though the Linotype itself has disappeared.

The factories in the old Altrincham area played an important part during World War Two, when production was almost universally geared towards the war effort. All kinds of companies were brought into the production of weapons, and armaments, instruments for planes and tanks, clothing for sailors, soldiers and airmen. The Linotype specialised in production of guns or parts

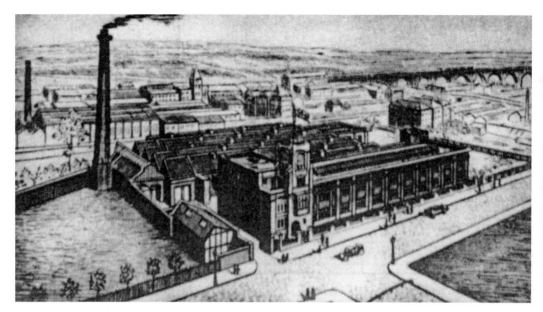

A drawing of Budenberg's factory on Woodfield Road, Broadheath, from an article in German, on the history of the firm of Schaffer & Budenberg from Madgeburg. The firm owned factories in London, Manchester, Broadheath and Glasgow.

Compare this photograph of Budenberg's factory with the previous drawing.

for them, such as the Bren gun or the Browning gun. The Record Instrument Company continued in production, supplying instruments for planes and ships. The need for machine tools increased during the war, so those companies that produced them like Churchill's, Kearns' and Richards' continued to do so. Women provided the workforce in many of the factories, while the men were called up to serve in the armed forces. In many cases there was no question of making a choice of where to go to work, because recruitment of labour was almost like conscription. Women who stared out in sewing factories could be chosen to fill vacancies in the engineering works, as priorities changed during the course of the war. After 1945, there was a backlog of work for most of the firms, and new ones set up outside the range of engineering and machine tool production. The nature of industry was changing all over the country in the 1950s and 1960s, as the austerity of the war years receded and consumerism developed. But there were hints of trouble to come. A guide to Altrincham compiled in the late 1960s reported optimistically that 'railways, roads and the canal are all to hand for easy transport of the town's products, which are very varied. Allowing for the drastic reductions visualised in the Beeching Report, goods will still be carried out with ease to and from Altrincham'. The result of the Beeching Report was the closure of many railways, including the railway that used to pass through Broadheath to Dunham, Heatley and Warrington.

It was not only the decline of transport that affected the industrial area of Broadheath. Frank Bamford has documented the demise of the large firms like Churchill's and Richards', which were taken over in the 1970s by other firms which failed to grasp the opportunities to expand their markets, perhaps not appreciating the changes in demand. The industrial estate at Broadheath still

The Linotype Works, Broadheath, set in open land, with work still going on in the left foreground. This is a Thornton photo, from the Thornton-Pickard works. It was posted in September 1904 to a recipient in Lytham, the message 'I hope you will like this view. You will know it quite well, I know'.

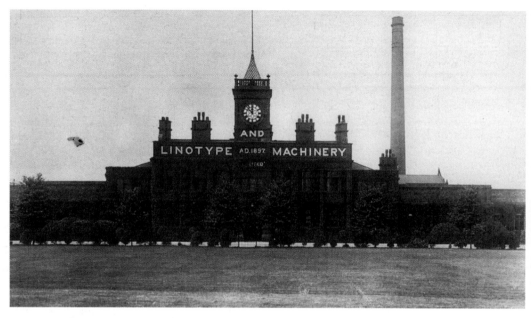

A later view of the Linotype, when the trees had grown in front of the building.

remains, and after a period of marked decline Atlantic Street has emerged in changed form with smart new buildings and new companies. The modern shopping patterns all over the country have been developed by trading estates where firms retail electrical goods, carpets, gardening equipment and DIY materials, like the one presently occupying George Richards Way, appropriately named as a reminder of the important contribution made by the first firm to establish an engineering works in the Broadheath area.

The heavy industry of the Broadheath industrial estate was supported by a host of other companies, such as the Altrincham Electric Supply Company, the Altrincham Gas Company, various coal dealers, plumbing firms, and other service industries. The Altrincham Gas Company was formed in 1846, after the enterprising manager of the Unicorn Hotel installed a plant behind the pub in 1844 to manufacture gas. It was successfully used to light the new gas lamps outside the hotel. In 1847 the Altrincham Gas Company opened a new gas works to the east of the town on Hale Moss. The coal needed to manufacture the gas probably arrived via the Bridgewater Canal, but very rapidly the railway took over, bringing coal to the yards at the back of the station and then transporting it by horse-drawn wagons. By the end of the nineteenth century a horse tramway superseded the wagons, and eventually steam engines superseded the horses. The North Western Gas Board took over the Altrincham Gas Company, and the end of the gas works came in 1957.

In the modern era the heavy industry has disappeared, in common with most other towns, to be replaced by retail parks and other businesses. After a period of neglect, Atlantic Street is once again a busy industrial estate, old factories have been re-commissioned and new ones have been built. Whilst employment figures will probably never reach those of the era of heavy industry, the current industrial outskirts of Altrincham are surfacing from their decline.

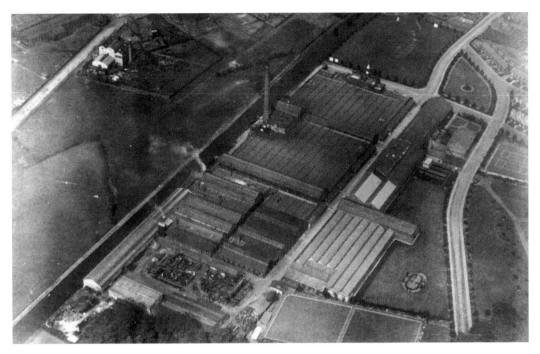

Aerial view of the Linotype Works, showing the full extent of the factory and how close it lies to the Bridgewater Canal.

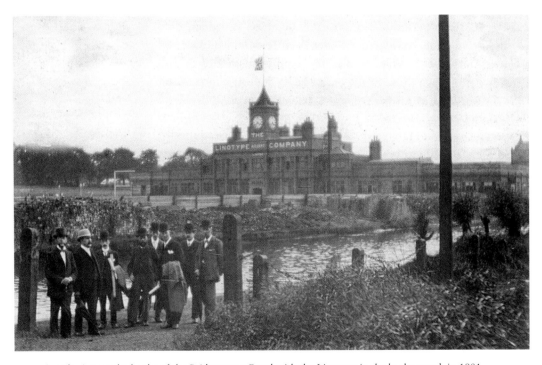

A gathering on the banks of the Bridgewater Canal with the Linotype in the background, in 1901.

A photograph from the Linotype brochure, showing cylinders awaiting assembly in

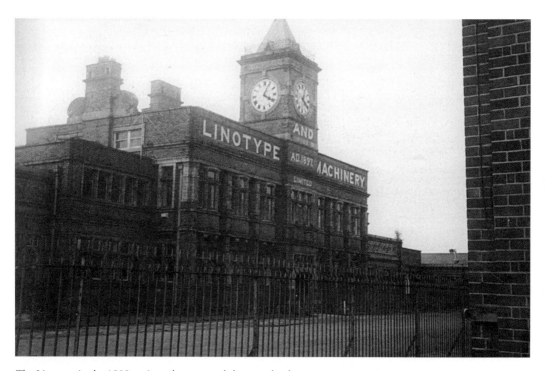

The Linotype in the 1980s, minus the trees and the open landscape.

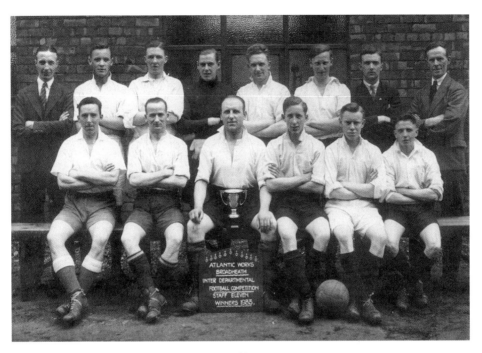

Local cup winners of 1933, the Atlantic Works staff team.

Asco Ltd, the Automatic Scale Company, as their title suggests, manufactured weighing machines. The company was set up in 1915 in Manchester, then moved to Manchester Road, Broadheath in 1918. The firm then took on extra work firstly to produce bacon slicers as well as scales, and sometime later the manufacture of refrigerators was added to the repertoire. During World War Two the firm diversified to make weapons and tools.

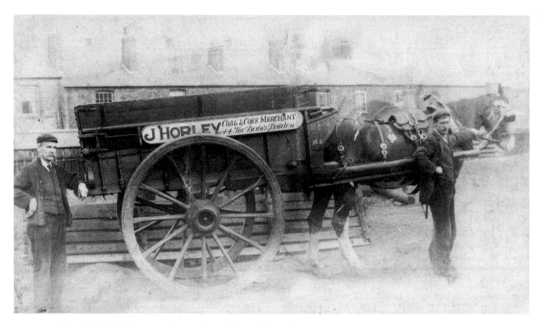

Horse and cart belonging to J. Horley, coal merchant, of 44 The Downs. This photograph was taken at Broadheath Station in 1910. Horley's had depots near the railway station at Broadheath and Peel Causeway, Hale in 1898. By 1916 Horley had moved from Broadheath to The Downs.

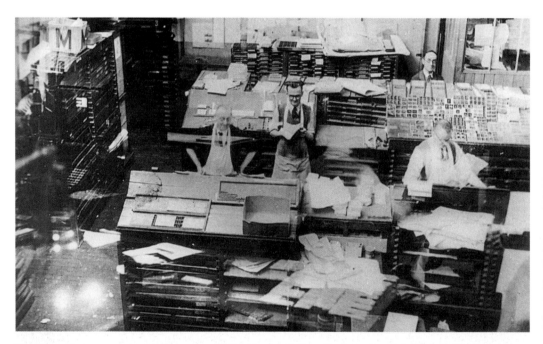

The composing room at the printing works of John Sherratt & Son, The Saint Anne's Press, Park Road, Timperley. On its early letterheads the firm is described as 'Formerly Sherratt & Hughes, The Saint Anne's Press of Manchester'.

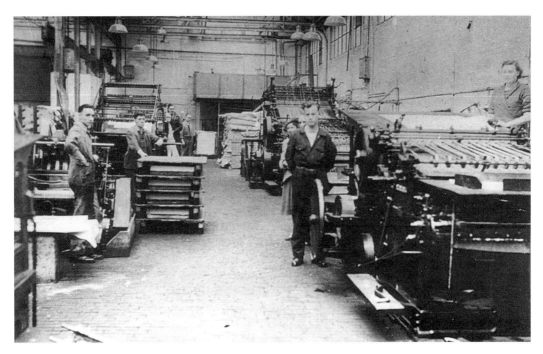

The printing shop at John Sheratt & Son, in 1951.

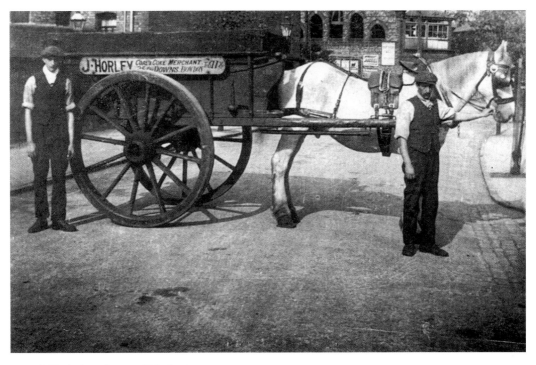

J. Horley's coal cart at Hale Station.

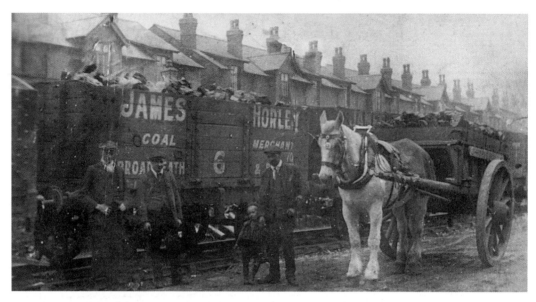

J. Horley's coal wagon on the railway being unloaded into the cart, in 1915.

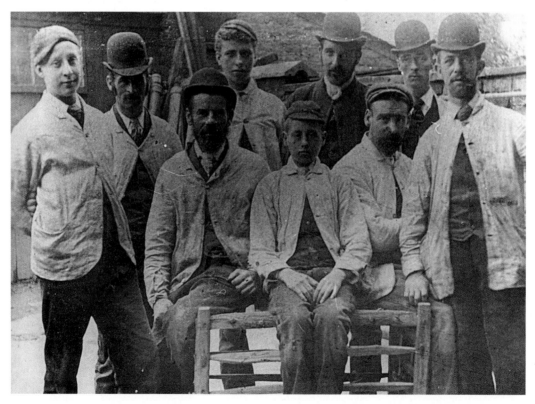

Workmen from the firm of Isaac Shaw, plumbers, line up for their group photograph c.1900. This was taken in the yard behind the workshops at No.26, The Downs. On the far right is Mr Hugh Jones, who was a founder member of Altrincham Photographic Society.

THE
Altrincham Rubber Co.
PATENTEES AND MANUFACTURERS OF PHOTOGRAPHIC APPARATUS.

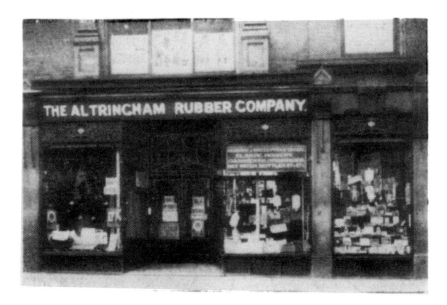

Anti-climatic and Arabesque Balls and Tubes. Sanderson Patent Automatic Timers for Shutters; Perfect Polish and Perfect Matt Squeegee Pads; Rubber Tripod Shoes. The Best Camera Cases in the World. Backgrounds painted in Flatted Oils, also Distemper and on Canvas and Paper; also Washable Cloth Backgrounds. Rubber Gloves, Finger Stalls. Shutters in various patterns such as Time and Inst., Focal-Plane, Studio Bellows and Roller Blind Studio. General Rubber Goods such as Water Beds and Bottles, Sheeting, Matting, Tubing, Hose, Etc. Etc.

☛ SEND FOR LISTS. ☜
40-page Catalogue sent free, mention this Guide.

THE ALTRINCHAM RUBBER COMPANY,
Mossburn Buildings, - ALTRINCHAM.

Advertisement for the Altrincham Rubber Company, 1910.

Interior of Altrincham Electric Supply, with the range of 'mod cons' that were on offer in the 1930s and 1940s.

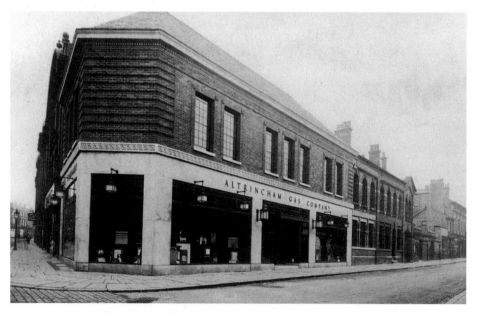

Showrooms of the Altrincham Gas Company on the corner of Stamford New Road and Cross Street.

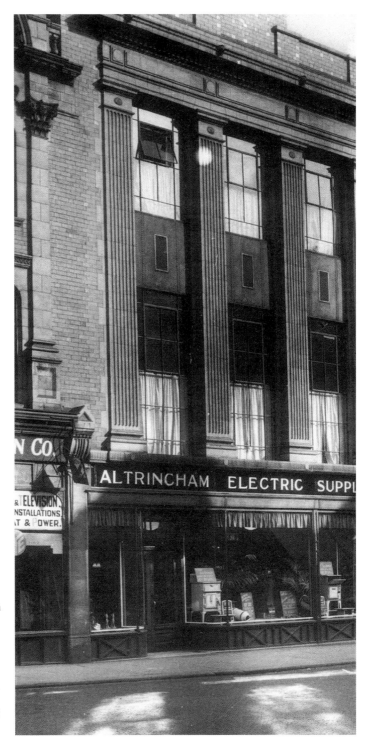

Showrooms of Altrincham Electric Supply Ltd on Stamford New Road. The main works was in Broadheath, by the side of Bridgewater Canal.

Chapter 6
Wartime

Altrincham played its part in both World Wars by contributing men and women to the war effort, by manufacturing armaments and uniforms, collecting money to provide ships and planes, and by surviving personal tragedies and the devastation of houses, shops and factories. The impact of World War One was felt at home in the loss of family members and privations; World War Two brought war much nearer to home.

Altrincham has its niche in the history of World War One in the famous story of the men from Chapel Street. Out of 60 houses, 161 men joined the army, and 29 of these never returned. They perished in different parts of the war zones and at different times, and likewise the men who served and survived to tell the tale were enlisted in different regiments. One of the men who joined up was already a soldier, having lied about his age to join the army during the Boer War. This was Joseph Norton, five of whose seven brothers also joined the colours. Several of the Chapel Street men joined the Cheshire Regiment; Thomas Booth and his two brothers from 50 Chapel Street, and James and Peter Morley from 2 Chapel Yard. Peter was only sixteen and was killed aged eighteen in France. A newspaper report from 11 April 1919 says that over seventy of the Chapel Street survivors marched in the parade through Altrincham, most of them 'as fit as fiddles' and ready and willing to shoulder arms again. This parade was held on 5 April culminating in the unveiling of the Roll of Honour in Chapel Street. The procession started off in Regent Road at 3pm, and the unveiling was scheduled for 4pm, by the Earl of Stamford. Permission to erect the Roll of Honour had been sought but not obtained from the vicar of St Margaret's, where it was intended to put the case and the scroll against the wall of All Saints' Church, which formed one side of the street. The Vicar was ill at the time and did not reply, so at the last minute permission was obtained from the Council to make the Roll of Honour a free standing monument on the pavement. A letter dated 2 April 1919 was read out in the Council meeting from Mr Joseph Butler, thanking the Council for permission to place the Roll of Honour on the curb in Chapel Street, meaning on posts on the footpath, as shown in one of the photos in this book. About half of the cost of the Roll of Honour had been raised by the inhabitants of Chapel Street, and a letter was addressed to the Council, asking for subscriptions. The minutes of the Council meetings reported it as follows:

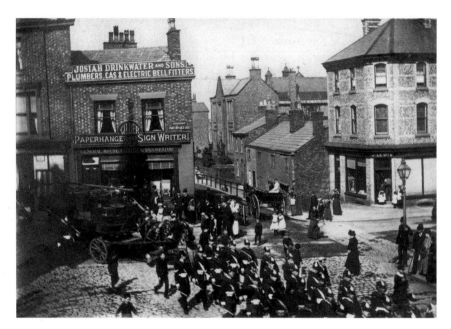

The third Cheshire Volunteers march into George Street, on their way to Tatton Park during the Boer War.

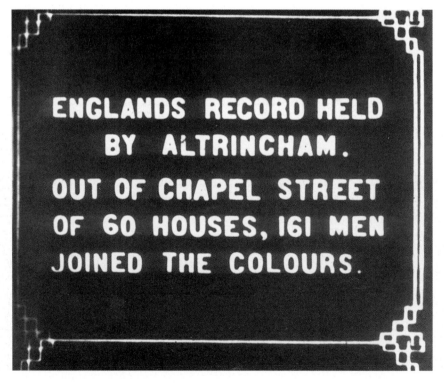

ENGLANDS RECORD HELD BY ALTRINCHAM. OUT OF CHAPEL STREET OF 60 HOUSES, 161 MEN JOINED THE COLOURS.

The contribution of the men of Chapel Street was recorded on film, at the parade to unveil the Roll of Honour listing all their names.

Chapel Street Roll of Honour: A letter dated 14th instant was read from Messrs Joseph Butler and Charles Nickson, asking for subscriptions toward the cost of the above Roll of Honour, the men and women of Chapel Street having collected about one half of the cost, a substantial sum of about £15 remaining to be raised. It was felt by the Council that they could not officially recognise the appeal and it was left for individual members if they themselves felt inclined to forward their subscriptions to the Clerk, and Mr Barber handed in his subscription of £2.

Full recognition of the sacrifice of lives from Chapel Street came from King George V, from whom a telegram was received and read out by Lord Stamford, congratulating the men of Chapel Street on their patriotism and fighting spirit.

Many others beside those from Chapel Street contributed to the war effort between 1914 and 1918, and the Council acknowledged this in their decision to erect a Memorial to all those who had been killed. Remembrance Day services still take place around the Cenotaph near St Margaret's Church, but the memorial is not on its original site, having been moved from the road where it hindered the flow of traffic. In 1919 the Altrincham Peace Celebration Committee issued a brochure outlining the history of the war, with portraits of the various heads of state, and a synopsis of the most important dates of the war. The brochure enabled most of the shops and businesses in Altrincham to advertise their products and services.

One of the lesser-known facts of World War One is that there was a prisoner of war camp for captured Germans at Broadheath. A short article about it can be found in *The Proceedings of the Altrincham and District Natural History and Literary Society* for January to March 1934, where it stated that Sinderland Road had to be diverted to accommodate the camp, and this new section of road was laid out by German prisoners. It is also said that in order to leave a record of their presence at Broadheath, the Germans buried a box full of mementos such as regimental buttons and badges, but only one person knew where it was. A note appended to the article says that since there is nothing of intrinsic value in the box, the Highways Department need not fear treasure hunters.

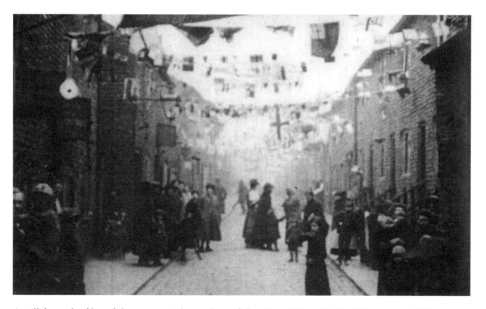

A still from the film of the ceremonial unveiling of the Chapel Street Roll of Honour in 1919.

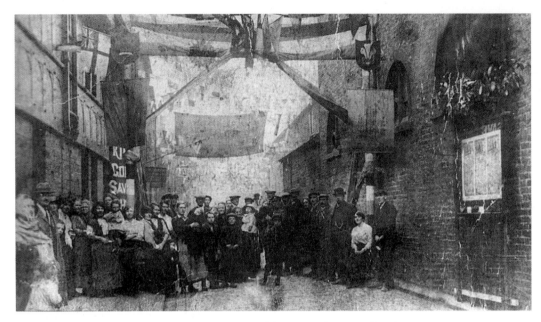

Here the Roll of Honour can be seen against the wall of the chapel that gave Chapel Street its name.

The dignitaries gather for a photograph round the Chapel Street Roll of Honour.

Worthington's advertise their raincoats and mourning clothes. The latter would be in demand by almost every family in Altrincham in World War One.

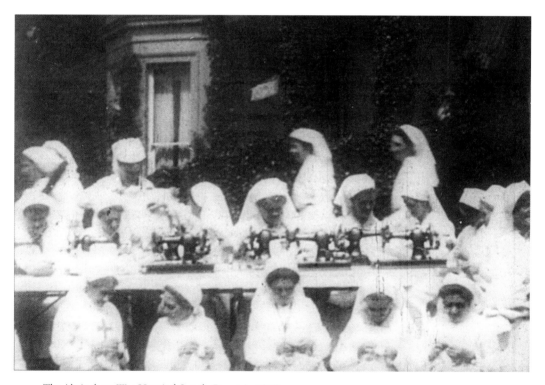

The Altrincham War Hospital Supply Depot in 1917.

The outbreak of World War Two in 1939 turned everyone's lives upside down. After the meeting of Neville Chamberlain with Hitler in 1938, though the official pronouncements declared that peace was assured, there was widespread but subdued activity to prepare for war. In the months before war was declared, both central and local government departments began to make plans, designating certain buildings as First Aid Stations, offices of the Assistance Boards, Billeting offices, Air Raid Precautions offices, with the relevant personnel assigned to each section. Booklets and helpful leaflets were issued, full of advice about what to do if there should be a war. One of these booklets advocated the establishment of a refuge room somewhere within the house, advising those who did not have a spare room to make a portion of the main room into a refuge. 'There is no need to do any of these things now' said the booklet, produced in 1939, but went on to advise people to gather candles and matches, hammer and nails, scissors, clean rags, and needles, cotton and thread, to stock the refuge room, and to collect or buy an electric hand lamp, gummed paper for sticking on the windows, plywood for blocking fireplaces, bottles of disinfectant, a first-aid box, and finally a radio to keep permanently in the refuge room to listen to the latest news.

The people of Altrincham who read these local government and national government leaflets perhaps reflected that in the event of a war the industrial and business premises at Broadheath, and the general proximity of Altrincham to Trafford Park and Manchester Docks, all served to ensure that the town would become one of the targets for bombing raids. In the fields behind Broadheath, stretching into Dunham, there was once a munitions dump, with large barn-like buildings well spaced out for the storage of explosives; these too would be prime targets, and even if not targeted, it would be just as dangerous if stray bombs fell in the vicinity.

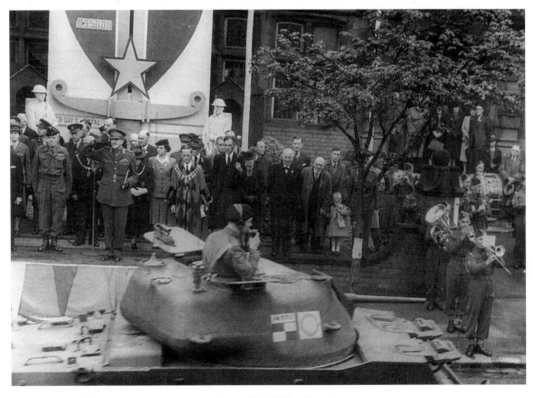

Parade at one of the many savings campaigns during World War Two.

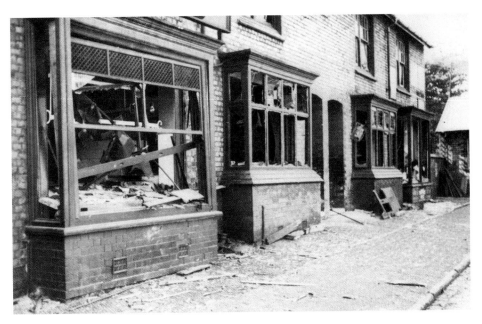

Bomb damage on Bath Street, after the raids of 28 August 1940.

The advent of war made enormous changes to every aspect of daily life. The call up of eligible young men deprived the factories of labour, a gap that was filled by women. Most of the industries of Broadheath and Trafford Park were converted to wartime production, including the sewing factories, such as the Bannerman's shirt factory on Moss Lane, where civilian production virtually ceased and uniform shirts of all kinds were made. The shortages of food and fuel led to the eventual introduction of rationing, and Dig for Victory campaigns, where each household with a garden was encouraged to grow vegetables instead of flowers. Special events such as radio broadcasts were arranged, shows and displays were put on, to answer people's questions, iron out problems and to encourage people to grow as much of their own food as possible.

Those members of the community who did not go to war still worked hard at home. Firemen, doctors, nurses, ambulance drivers, first-aid personnel, the Women's Voluntary Service, the Air Raid Wardens, and the Home Guard all had a part to play, sometimes in dangerous circumstances. At least one occasion was a pleasurable one, when the first Battalion of the Cheshire Home Guard put on a display at Altrincham Grammar School for boys at their grand fete, on Saturday 22 August 1942. The commander was Lt Col G.W. Crawshaw, and the chairman was Major C.A. Price. At 3pm the band of the Cheshire Home Guard opened the proceedings with selections from their repertoire, and from 3.30 to 4.30 there were various displays, including gymnastics, precision drill, a camouflage demonstration, and an attack on a pill box. There were also competitions and sports events for children, and in the evening a dance and cabaret. Since it was wartime, the programmes included information on what to do if there was an air raid:

In the event of AIR RAIDS or GAS the following will be observed: women and children will proceed to Air Raid Shelters, south of the school buildings. Male citizens will be accommodated in the school buildings. Home Guards will be dispersed round the field under cover. These arrangements will be announced through the loudspeaker.

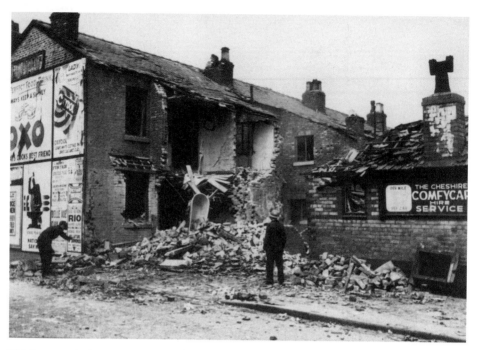

This house on Bath Street was completely destroyed on 28 August 1940.

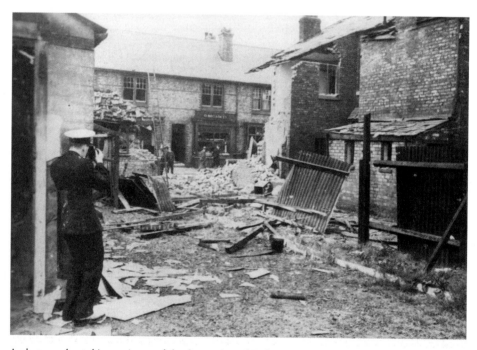

A photographer taking a picture of the destruction of Bath Street in August 1940.

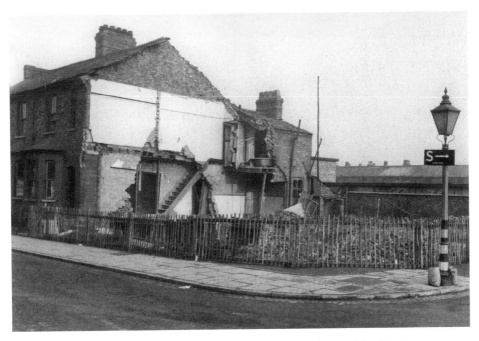

The raids of December 1940 caused considerable damage. This is what was left of the houses on
Oakfield Road.

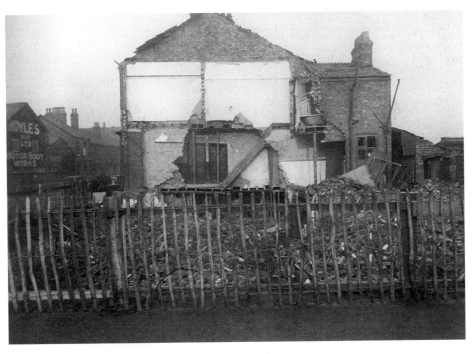

Another view of the damage on Oakfield Road in December 1940.

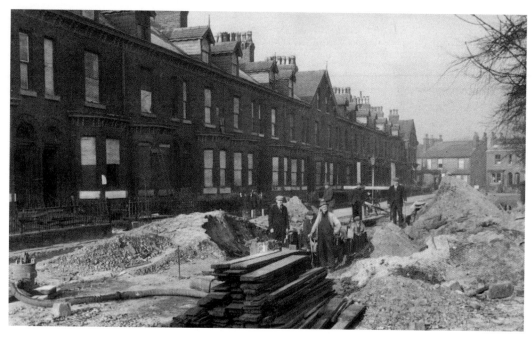

Charter Road was hit in August and December 1940. This photo shows workmen repairing the damage after the December raids.

Tyler's shop on the corner of Mayor's Road and Charter Road was blown out in the December raids.

The WVS helped to organise reception of the evacuee children in Altrincham, and distributed clothing to those who had been bombed out of their houses. Rest centres were organised, staffed by the WVS, thirteen of them dedicated to evacuees and seven earmarked for those who had been bombed out. 250 people were made homeless on the first night of the air raids in August 1940, and were housed in the rest centres until new dwelling places could be found. The WVS could always be relied upon to come up with the national restorative, cups of tea – not as easy as it sounds in the circumstances. 4,422 children arrived from Manchester on 2 September 1939, and were somehow accommodated in the town. Evacuees were sometimes accompanied by their mothers, who arrived tired and bewildered by the travelling and the uncertainty of it all and the WVS took care of them until homes could be found. The women also knitted garments for the men in the various forces, and dispatched these and gifts to the service men.

All over the country projects were put into operation to raise money for the war effort, to provide weapons, planes, ships and tanks. Altrincham played its part in these schemes, raising money during Salute the Soldier Week, a leaflet was circulated encouraging Altrincham people to save £425,000 to adopt HM Submarine *Talisman* and as the leaflet announced this sum 'means £11 from every family'. When it is remembered how much people earned in a week, this was a vast sum. The leaflet announced the terms of the savings campaign:

The Nation needs your savings NOW. You will receive interest on your loan and your money will be repaid in full on the date announced. No amount is too small or too large. If all will lend according to their means we can easily raise the cost of a submarine for the Navy, which will then carry a special plate stating that its cost has been raised by the citizens of Altrincham.

Houses on Park Drive, Timperley were damaged by bombs in 1940.

Special concerts, luncheons and parades were held during Warship Week to encourage people to participate. The co-coordinating office was on 33a Kingsway, and people could make deposits or buy Defence Bonds or Savings Certificates at Post Offices and banks, or in their factory and workshop groups. In January 1941 and February 1942 War Weapons Week was organised. Altrincham raised £422,679 for Wings for Victory Week in 1943, and over £410,000 for Salute the Soldier in 1944.

The most vivid memories of Altrincham in World War Two concern the bombing raids. After the so-called 'phony war' from September 1939 onwards, when things in Britain seemed to carry on much as normal, enemy bombers started to strike at industrial installations all over the country. The first bombs fell on Altrincham on the night of 28 August 1940, just after 10.30pm. Two petrol tanks were hit near the Bridgewater Canal, and caused a terrible fire as 25,000 gallons of petrol went up in flames. This was the first of many raids that imposed a new routine on families living in the area, "Come on, let's get our tea over before they come", then the sleepless night spent in the Anderson shelter, and the cycle ride to work next day through the debris. Not widely publicised at the time so as not to upset public morale, a few will still remember lines of dejected people streaming out of Manchester with the remains of their belongings on prams and carts after a night raid. Others will remember the detours that were sometimes necessary to circumvent bombed areas, the perils of going out late at night in the blackout, with the first casualties often caused by walking into lampposts, the wail of the warning sirens and the all clear, the drone of the bombers, and the explosions: "Somebody's copping it tonight". My mother tells the tale of one of her school friends, a local farmer's son, who had found an interesting looking ball in the fields. "I've been bouncing it all the way here", he said and proceeded to show everyone how it bounced, this time on the cobbles of the house yard. Thus went off the first privately aimed magnesium incendiary in somebody's back yard, and only by a miracle did the watching children escape injury.

The most serious raids of all were those of December 1940, just before Christmas. On Sunday 22 December the warning sirens went off around 6pm and the raid continued all night until roughly 6 am. The whole area including Altrincham, Sale, Stretford and Trafford Park was affected. On this

In October 1941 parachute mines landed on the Broadheath area, causing damage to the houses and shops on Wright Street and Huxley Street. This photograph shows houses at the centre of the explosions.

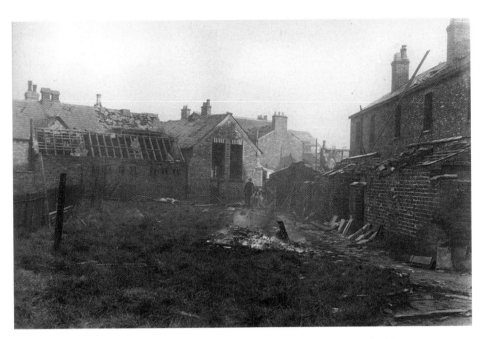

Houses all around the Wright Street and Huxley Street area were damaged by the blast.

night the worst casualties were in Timperley, in Sylvan Avenue, Woodhouse Lane, Crofton Avenue and Manchester Road. A great chasm was blown out of Charter Road in Altrincham, and twenty houses in Lawrence Road on the Linotype estate were seriously damaged, but it is not recorded that the factory was hit. One bomb fell into the tanks of Altrincham Sewage Farm; there is no record as to whether it exploded, or how it was removed if it did not. On the following night the bombers returned, and this time there was more damage in Altrincham itself, in the Moss Lane area, where a house on the corner of this road and Oakfield Street was demolished. Three children and nine adults were killed. Buildings were damaged on Hamon Road and Charter Road was hit again; Holt's Builders Yard received a direct hit. The raids then diminished through 1941, until 25 October when the Broadheath area was attacked in earnest. Parachute mines were dropped, but did not strike the centre of the factory area. This was when the houses on Wright Street and Huxley Street were demolished or damaged, as bombers aimed for the factories and missed. Three women and five men were killed, one of them a seventy-one-year-old air raid warden. Some people were buried in their houses, and miraculously rescued from the debris. In total between the first raid in August 1940 and the last serious one in October 1941, 26 people were killed, 31 were seriously injured and 73 had minor injuries. 1,122 houses were damaged, and 268 suffered heavy destruction.

After the war there were still reminders of it in the destruction to be cleared, the houses to be repaired or rebuilt, and the prisoner of war camps in the area, one of which was at Dunham Park. The German soldiers there built a large model of a castle, to pass the time. Memories of World War Two now reside mainly in the minds of those who experienced it, and in contemporary newspaper reports, photographs, and books written after the event. The photographs in this book record a small part of it. It is the author's opinion that everyone should be encouraged to write down his or her experiences and memories. If nothing else comes to mind, everyone ought to know where they were, or who they were with and what they were doing, on the nights of VE day in May 1945, and VJ day in August that year.

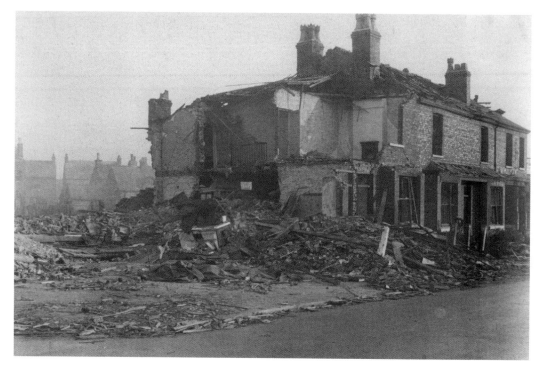

The land mines brought total destruction to these houses in the area of Wright Street and Huxley Street in October 1941.

Houses at the rear of the Cheshire Cheese were damaged by the land mines in October 1941.

This photograph shows how serious was the damage caused by landmines to the houses in the Wright Street and Huxley Street areas.

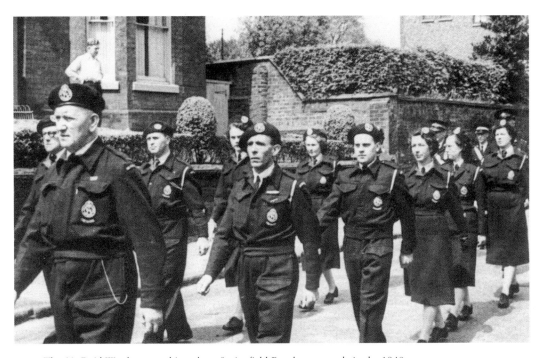

The Air Raid Wardens marching along Springfield Road at a parade in the 1940s.

Demonstrating how to put on the gas mask.

Altrincham HQ staff of the Air Raid Wardens organisation, photographed at the end of the war on 5 May 1945.

The first Battalion of the Cheshire Home Guard march past after demonstrating an attack on a pillbox, during the events at Altrincham Grammar School on 22 August 1942.

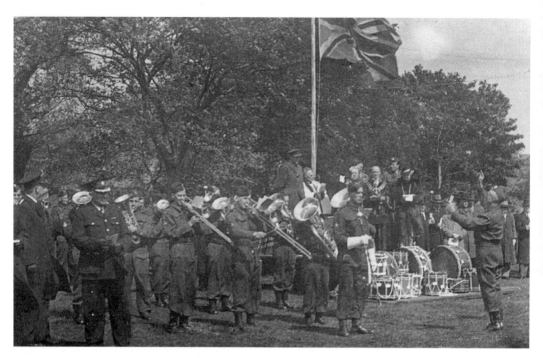

Home Guard drumhead service, c.1943.

The miniature 'Bavarian castle' built by German prisoners of war at Dunham Park.

The mayors of Altrincham (Sidney Garner) and Sale (S. Mayer) inspect the castle built by prisoners of war at Dunham Park in 1945. With them are the town clerk of Sale, Bertram Finch, and the officer commanding the prisoner of war camp.

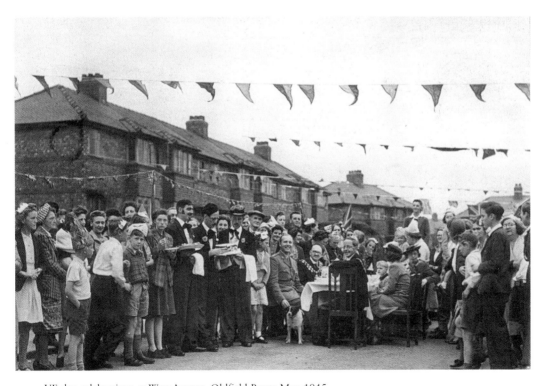

VE day celebrations at West Avenue, Oldfield Brow, May 1945.

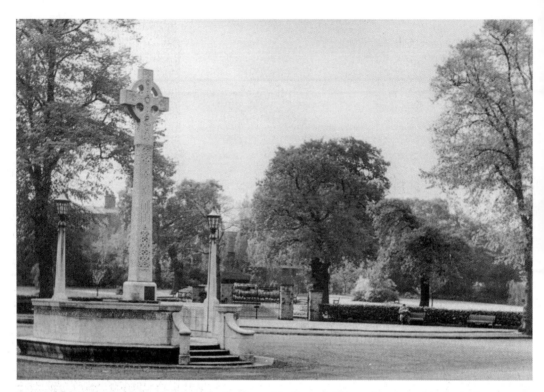

The cenotaph at St Margaret's Church used to be situated in the road, but was later moved to the garden facing the church.

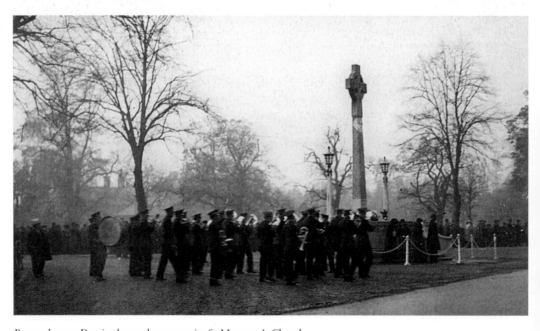

Remembrance Day in the gardens opposite St Margaret's Church.

The Cenotaph in its old position, in front of the church.

Bibliography

Bamford, F. *Broadheath 1885 – 1985: a century of industry*. Published by the author, 1995.

Bayliss, D. (ed.). *Altrincham: a history*. Willow Publishing, 1992.

Bayliss, H. *Altrincham: a pictorial history*. Phillimore, 1996.

Fitzpatrick, G. *Altrincham Past and Present*. Willow Publishing, 1990.

Millichip, M. '*Altrincham Gas Works*' Railway Bylines vol. 5 issue 5, April 2000, 196-204.

Morrison, B.D. *Looking Back at Altrincham* Willow Publishing, 1980.

Nevell, M. '*The Old Market Place, Altrincham*', Archaeology North West: the Bulletin of CBA North West. Vol. 5, issue 5, 2000, 18-28.

Rendell, D. *The Cinemas of Trafford: a souvenir of 100 years of cinema*. Published by the author, 1998.

Rendell, D. *The Thornton-Pickard Story*, Photographic Collectors Club of Great Britain, 1992.

The Town and Trade of Altrincham. Printed by Mackie & Co 1897.